I'd Rather Live in Buxton

le 6 mai, 2003
J'espère que tu aimes mon livre.
Ton amie,
Kas..

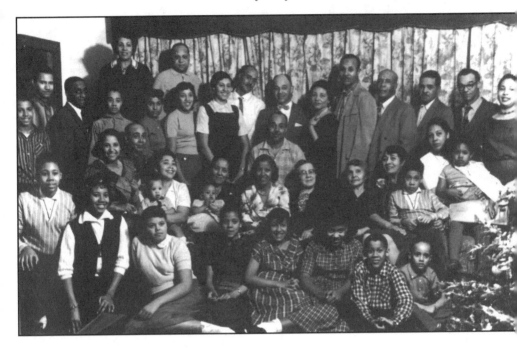

I'd Rather Live in Buxton

Karen Shadd-Evelyn

Simon & Pierre

The writing of this manuscript and the publication of this book were made possible by support from several sources. We would like to acknowledge the generous assistance and ongoing support of **The Canada Council, The Book Publishing Industry Development Program** of the **Department of Communications, The Ontario Arts Council,** and **The Ontario Publishing Centre** of the **Ministry of Culture, Tourism and Recreation.**

Kirk Howard, President; Marian M. Wilson, Publisher

ISBN 0-88924-242-9
1 2 3 4 5 • 8 7 6 5 4
Simon & Pierre Publishing Co. Ltd., a subsidiary of Dundurn Press

Canadian Cataloguing in Publication Data

Shadd-Evelyn, Karen, 1958–
 I'd rather live in Buxton

ISBN 0-88924-242-9

1. North Buxton (Ont.) – Fiction. 2. North Buxton
(Ont.) – Poetry. 3. Blacks – Ontario – North
Buxton – Fiction. 4. Blacks – Ontario – North
Buxton – Poetry. I. Title.

PS8587.H34I4 1993 C813'.54 C93 095036-4
PR9199.3.S43I4 1993

Photographs: Photograph of The Liberty Bell courtesy Raleigh Township Centennial Museum, North Buxton, Ontario. All other photographs are used by permission of the author.
General Editor: Marian M. Wilson
Editor: Jean Paton
Printed and bound in Canada: Metropole Litho Inc., Quebec

Order from Simon & Pierre Publishing Co. Ltd., care of

Dundurn Press Limited	**Dundurn Distribution**	**Dundurn Press Limited**
2181 Queen Street East	73 Lime Walk	1823 Maryland Avenue
Suite 301	Headington, Oxford	P.O. Box 1000
Toronto, Canada	England	Niagara Falls, N.Y.
M4E 1E5	OX3 7AD	U.S.A. 14302-1000

This book is dedicated to the memory of
Robby Shane Robinson

in the hope that an improved understanding
of the common denominators of humanity,
and an appreciation for its differences,
might somehow abate the existence of the racism
that took him from us,
and the injustice that pardoned it.

Sleep sweetly, Shaka.

Acknowledgements

I could not have compiled these stories alone. I would like to express my thanks especially to the following people:

- first and foremost, to my sister, Joyce Shadd Middleton, whose avid pursuit of our history first intrigued me with the Buxton story, who helped me keep my facts straight, and who gave me invaluable assistance, encouragement and support;
- to all four of my sisters and my brother, who share the memories of so many of the stories, and forgave me for putting them in print;
- to my husband Dennis, who encouraged me, and who, along with my girls, tolerated the down side of my writing;
- to the people of Buxton, those who see themselves in these pages and those whom I'm saving for the sequel, those I talked to during this process, and those I talked about, past Buxtonites, present, and future;
- and to the memory of Eileen and Owen Shadd, for being what you were, and helping your children become what we could be.

Finally, I would like to acknowledge the financial assistance (and the boost to my morale that accompanied it) of the Explorations Program of the Canada Council, as well as the Ontario Arts Council Writers' Reserve, in the compilation of these stories.

Arlie Robbins, a Buxton native who recorded its history in her book *Legacy to Buxton*, to which I am indebted for many of the historical facts herein, paved the way for its continuing saga in her concluding statement: ". . . the North Buxton story will continue to be written in the everyday lives of its people." Here, then, is the next chapter.

Table of Contents

Introduction

Nearly one hundred and fifty years ago, November 28th, 1849, Reverend William King moved, with the fifteen former slaves he had inherited and subsequently freed, onto the land that would soon become the bustling Elgin Settlement. Some thought him a madman, a dreamer, his vision of a self-sufficient community a far cry from the heavy bush and swampland that they found. But beyond those forests he saw a haven, where the former slaves, well used to heavy labour, though never on their own behalf, and the free Blacks seeking a shelter from the constant threat of being kidnapped into slavery, could provide for themselves the necessities, and then the niceties, of Canadian living. Once tiled and drained, the swamps that confronted the farsighted King and his party would come as near to the Utopia they sought as any place could. For their Paradise would be a place built by and for themselves, where they could realize the fruits of their own labours, and claim the freedom that should have been their birthright.

Most of King's life would be dedicated to the planning, the founding, and the functioning of this vision, which came to pass with unequalled success. The settlers had not settled for necessities, and industry had flourished. After homes had come churches and schools. And after those, a post office, stores, a temperance hotel, a blacksmith shop, pearl ash and potash factories, a brickyard, a sawmill and a gristmill, a carpentry shop, and a shoe shop all ranged around Buxton Square.

Today the village remains, the only example still in existence of a Black Canadian Community established before the civil war. Known officially as North Buxton, called simply Buxton by its residents and alumni, the former last stop on the Underground Railroad still harbours many of the descendants of those original settlers. Only a fraction of the estimated two thousand citizens of its zenith, the tiny hamlet now numbers somewhere under two hundred. A large part of its population returned to the States after the emancipation proclamation, to

find the lost loved ones they had left behind and pass on the lessons they had learned of self-sufficiency, and self-determination, in Buxton's classroom.

Still, it remains a community which has preserved the cooperative way of life with which it was begun, and remembers its role, and its roots, in North American Black history, and in the history of Canada.

The culture of Buxton's citizens, though for the most part indistinguishable from that of the majority of Canadians of this region, still holds some unique qualities as it functions as a haven for its community within the Canadian mosaic. The support systems of this "society within a society" emanate from the spirit of the people, cultivated by an upbringing which may be unique to the particular shared circumstances of their background which brought them here.

My parents gave each of their six children a copy of *Look to the North Star*, by Victor Ullman, the year I was twelve. I didn't read mine until I was thirty-two. It was the story of Reverend King's life, but more than that it was the story of our ancestors. It was the story of how we had come to this place, and what this place had once been. The treasure I had unwittingly hoarded until I was old enough to appreciate its value unfolded the drama behind those facets of life I had grown up taking for granted. Suddenly I could see the patterns, the reasons, the whys and wherefores of Buxton's traditions, the customs we learned as children having grown from that early settlement.

The home-centred lifestyle, the emphasis on education, the rarity of alcohol, the strict upbringing and the dominance of religion in our lives, were outlined in the pages of this marvellous revelation, and had sprung from our forebear's foresight. The inexorable bonds of kinship that had grown out of this way of life were like anchors in a strong wind: we bound ourselves with, and to them. And we had just considered ours ordinary lives!

The presence of these qualities of life in the settlement had been remarked by a daughter of one of those early settlers, Hattie Rhue Hatchett, in her poem *Memories of the Old Home*, which reads in part:

They were 'mong the early settlers
When the land was bush and bogs
When you had hard work to travel
Climbing fence and walking logs,
When your devious pathway led you
Miles and miles from off your course
When the oxen team was surer
Than the spanking team of horse
When great ice-fields lay before you
Aft your foot-steps breaking through
Thus they laboured for their loved ones
Did dear Jane and William Rhue
Going forth to sell and purchase
In young Chatham town so fair
Getting something that was useful
For each tender, loving care
We held morn and evening service—
Those were happy moments all
When the family assembled
'Round the fireside—great and small;
And we sent our voices ringing
Up to God, in prayer and praise
Many prayers went up before Him
In this home of former days
In deep fancy I see Mother
At the old loom weaving now
With her face lit up with sunshine
And a smile upon her brow.
And our father in the big woods
Felling trees with massive blows—
How they conquered all their hardships
Only God in heaven knows

This emphasis on home and family life, on self-sufficiency, on religion, and on education, had evolved in Reverend King's time, and was still prevalent in the Buxton of my childhood,

several generations removed from the hardships of which Mrs. Hatchett wrote.

It is my aim to capture some of the extraordinary spirit of this ordinary place. It is only a typical small Canadian town now, but the factors that shaped its history moulded our future in unique ways. The unsung lives of these everyday people resulted from the so-called "experiment" in the colonization of their ancestors, who were survivors of the American system of slavery. There were an estimated forty thousand escaped slaves in Canada when the civil war broke out in 1861. The stories of these families are many and varied. I have attempted here to continue the saga of a few of the ones who landed in Buxton, and put their roots down.

The stories are meant to define the character of the community, rather than to depict actual occurrences. They are not meant to be definitive of Buxton or its people, but rather of their essence, as seen through the eyes of one who drew strength from its solace. Some details have been changed, a few created, many omitted, in an effort to convey the spirit of the place, that special quality that draws its people to return, and compels them to think of it, fondly and always, as home.

Circa 1870–Papa Brimell's Carriage Ride

He always wore his Sunday best when he came into town. Homespuns were fine for the farm, but now that he was a free man, he intended his neighbours to see him looking like one. A horse and open buggy might be fine for the rest of the folks around, too; but his spare moments for two entire winters had been taken with felling, chopping, bundling and selling extra firewood toward the purchase of the fine conveyance beneath him now.

He preferred the elegance of his carriage, the matched pair of geldings stepping smartly before him, his wife and two daughters looking sedately out the fringe-trimmed windows, wide bonnets framing prim faces. He snapped the reins dramatically at the precise instant of his arrival onto Buxton Square.

You never saw him drive that carriage without his trademark cigar clamped firmly between the firm-set jaw. He removed it politely to salute those he passed in the street, even doffing his dapper top hat to the ladies, his expression never wavering as he returned cigar and hat each in turn to its appointed place.

He never knew, of course, that I had had occasion to visit his pantry once. When his daughter asked me to reach down a jar of dill pickles from the top shelf, I had seen that cigar in the covered glass jar, where it awaited her father's next carriage ride to town.

Circa 1915–Toddy for Two

The snow had made her bare foot numb, and the other, covered by a trailing and sodden woollen stocking, only slightly less so when the child arrived at the kitchen door of the Rices, their Irish neighbours. She was only short moments behind her older sister, who had celebrated her seventh birthday just last week. The Rice farm was almost a half mile from their own kitchen door, or at least where the door had stood the last time Dorothy had dared to glance back over her shoulder. The flames had been licking their way toward it from the upper outside wall.

She had been chasing Hazel around the dining room table when her brother's shout had come from the upper level, where the older boys slept. Fire was no stranger to this family, who had lost countless crops to the ravages of cinders thrown from the wheels of the railroad cars that cut across their fields.

Galvanized into action, the older members of the household (and there were many, for she was second youngest of twelve children) had immediately begun a bucket brigade from the water pump at the kitchen sink to the bedroom wall, which was by now fully ablaze. It was soon realized to be a futile effort, and they turned their energies instead to saving what they could.

Hazel, until now mesmerized by the activity, had seen Mother carry the baby, cradle and all, out into the snow and set him under the tree near the laneway. She decided it was time to make her exit. She'd still been wearing her shoes, and had stopped only long enough to snatch her coat from its hook by the mantle, pushing her arms into the sleeves as she ran for the side door, and off down the laneway to the road.

Five year old Dorothy, who followed Hazel everywhere, knew
that if she stopped to put on her shoes, or even her coat, Hazel
would be long gone, and she'd be left to run alone in the dark.
She didn't know where they were going, but she knew they
were going together, and dashed out after her sister.

She'd soon determined they must be going to the Rice's.
There was nothing much else in that direction. Beyond that
she could not think, because one stocking had come loose, and
down, and off, and she had not stopped to retrieve it. While
the rest of her body was stiffening with the cold, making
running difficult and jerky, the icy pain in her feet had become
only a mild tingling in the stockinged foot, and none at all in
the bare one.

The little girls were not yet aware of what had caused the
fire that left their large family lodged with various relatives for
the rest of that winter. They had pushed the bed they shared
up close to the chimney the night before, and slept warm and
cosy from the heat of the dying embers in the grate below. But
when the fireplace had been fully stoked and lit after supper
the next evening, the bedclothes against the chimney had been
set ablaze by the force of its full heat.

By the time their mother arrived with the baby at the
Rice's, where she and the three younger children would spend
the next several nights, Hazel and Dorothy had been dried
and wrapped in heavy blankets by the fireplace, and the
stinging that had made her cry when they first began to warm
had almost completely gone from the soles of her little feet.
The toes still hurt a bit, but the pain was ebbing. Mr. Rice had
gone to help their dad and the older boys keep the embers
away from the outbuildings, but the house was a rubble of
smoke and ashes, the few furnishings they'd managed to
carry out sitting forlornly under the branches of the big old
elm nearby.

Mrs. Rice made Dorothy drink a toddy, made with whisky and hot water, before putting her to bed. It was supposed to keep her from getting sick from her exposure to the cold, Mrs. Rice told her mother. She'd made one for the baby, too, but he refused to drink after the first sip. Dorothy wished she could refuse too, but swallowed it under Mother's scrutiny. Her mother carried the baby in one arm; the other hand held his glass of the nasty stuff as they followed Mrs. Rice to the room that had been vacated for them.

Some time during the night the baby woke, as he always did, for a drink of water. Mother had known he would, and retrieved the glass she'd set on the wash stand near the bed. Owen drank the toddy down without even a whimper of protest, lay down and went immediately back to his slumber.

Neither child was any the worse for the chill they'd suffered that night. The remedy had fulfilled its promise, and by spring, when their father began to rebuild, Owen was walking, and followed Dorothy everywhere.

Circa 1950—...And a Good Time Was Had by All

When Buxton had a good time, it was had by all, and the white folks round the township soon knew by word of mouth when the next street dance would see the village jumping. They came at first as spectators, hesitant to mingle, or perhaps afraid their presence was unwelcome. But detecting no hostility, the music proved infectious, and their faces soon filled out the missing squares.

The fiddlers were fiddling, the guitar picker twanging as the square dance caller called out to the pairs.

> "Now swing your partner, do si do
> Round the circle now you go
> Allemande left and step up light
> Get another partner from the right
> Allemande right now and don't be late
> Step up the middle and close the gate."

The music floating out over the summer night carried the throaty-voiced commands directing the dancers, full skirts swirling over yards of crinoline, through the Virginia Reel and on into the Kentucky Running Set before taking a break.

Joining her husband at the soft drink stand, she heard his companion, a fellow from out Fletcher way who stopped into the store quite often, but had never before been to one of the dances, offering his humble opinion. "I'll be back. I'm having a great time here. But my God, Ira, that woman of yours!"

Like most newcomers, she knew it would take him some time to adjust to a female calling the sets. It was not a new reaction, and her hearty laughter rang out with her husband's

as the fellow turned sheepishly, following the direction of Ira's
eyes, now twinkling with mischief, to discover her standing
there behind him. Crimson-faced, he soon joined in their
laughter, and the three of them shared a round of the fruit
punch she'd dubbed Rutabaga Slop.

Between the 8th and 98

Between the 8th and 98,
Two highways of renown,
An empty stretch down centre road
Unveils a tiny town.

It's just a village, really,
Where the folk are commonplace,
And the action ordinary,
And life keeps a quiet pace.

It's only small town Canada,
The same as anywhere.
Most ordinary kinds of things
Are all that you'll find there.

There's nothing to remark it.
It's just a patch of soil
Where farms stretch out for miles between
And common people toil.

There's no grand architecture,
No landmarks for impact.
In fact, it's flat and featureless
And barely on the map.

'Tis only homes you'll see there,
Two churches and a store,
A hall, park, and museum;
It could be quite a bore.

No metropolis of factories.
Streets all rolled up at night.
Don't blink or you will miss it.
Mine's the first house on the right.

I tried the living elsewhere,
So I know whereof I speak.
'Tis the essence of this little town
That makes the bland unique.

For this stretch of land is Buxton,
And no matter where you roam
The current coming from the place
Will draw your spirit home.

Uncle Ira

The village of North Buxton was home to slightly over one hundred residents as I was growing up. We considered ourselves to be among that number, although technically we lived outside the village proper, an empty mile down the usually deserted highway which, when it reached Buxton, functioned as Main Street for about three-quarters of a mile, before becoming the highway again.

Once the centre of a thriving Black community known as the Elgin Settlement, Buxton's population had, over generations, been reduced mostly to residents with young families, or people close to retirement age. For anyone in between, it was a place you left after high school, returning at least annually on Labour Day, and perhaps settling back there to raise your own family, or, failing that, when it was time to retire.

Being a small and loosely organized community, there was no need in Buxton for any sort of hierarchy. Back in 1850, when the little village was busy becoming the bustling Elgin Settlement, a five-member Court of Arbitration had been elected to handle any disputes which arose. But in its first two-year term there were only five cases to be heard, and its time became increasingly occupied with community matters, celebrations, emergencies, industrialization, and the general operations of the settlement. It had become the governing body during the boom years.

Now, however, community business was conducted mostly through word of mouth and general consensus. Buxton had no city hall, no city council, because, of course, it fell so far from being a city. Even the designation of Town was above its aspirations. There was a Police Village a few miles

up the road, so designated because its contingent of OPP officers patrolled the township from their headquarters there. But Buxton was only a village, and even that designation was not official recognition, but only the way those of us who lived there referred to it. Buxton had no organized government, no official system of decision making, no delegated or elected officers. We had no mayor. But we did have Uncle Ira.

Uncle Ira was my father's brother, and the resemblance was unmistakable, and becoming more so as they grew older. Both copper-brown faces were seamed with the lines of laughter, and the lines that come with the task of raising large families. They were reputed to have been quite popular with the young ladies in their youth, and both faces still bore evidence that reputation was justified. They were of average height and build. Daddy was perhaps a bit broader of shoulder because his business was one of physical labour, while Uncle Ira's was more of a service occupation. The brothers used to cut each other's hair on the rare occasions when barbering was required. Since they both bore exactly the same shiny brown scalp, they knew best how they liked the hair which clung persistently to the edges, the black and mostly grey fringe grown long on one side and swept over the dome. The only difference was that while Daddy's was often covered by the engineer's cap he wore on the job, Uncle Ira's was usually visible as he attended to the patrons of his general store. The only store in Buxton, it was also the main source of information, gossip, and entertainment for most of the inhabitants.

We children considered it the only place worthy of note in the entire village. It was at Uncle Ira's store that we congregated, when we congregated at all. It was there that we spent our nickels and pennies, selecting carefully from the

variety of licorice, bubblegum, and penny candy kept in large glass jars on the pock-marked counter. And if one of us was down on our luck, and managed the right woebegone expression, Uncle Ira would quietly slip a "sample" into a small brown hand, receiving a grateful smile and undying gratitude in return.

I shall never forget the day I decided that helping myself to a piece of Double Bubble when his back was turned really wasn't such a bad thing. After all, he'd surely have gotten around to giving me one eventually. I left the store shortly thereafter, waving goodbye to my friends and shouting back along the road to them until they were out of earshot. Humming and skipping along, chewing my Double Bubble, and occasionally stopping to examine some flora or fauna along the way, I made my way down the mile or so of road to my home. The teenage brother of one of my friends passed by on his new motorcycle, stopped, turned and came back to me. He offered me a ride home. I wasn't even tempted. He persisted, determined to show off his new possession. I declined. Though I'd never even been this close to a motorcycle before, I knew what Mom's reaction would be if I entered the laneway on the back of one. So, thanking him politely, and watching with more than a little regret as he sped off, I continued my walk-skip-walk, feeling the self-satisfaction of knowing what a model of good behaviour I presented.

I was still humming as I entered the kitchen door. The look on Mom's face stopped the note in mid-vibration and I mentally scrambled over the terrain of the day, searching for my error. I had not accepted the motorcycle ride. I was home on time. I had not forgotten to do my chores before I left. There must be some mistake.

"Where did you get the bubblegum?" There was no

feigned innocence to the question. It was straight accusation.

I had completely forgotten. In fact, it was so normal for me to come home from Uncle Ira's chewing gum that it didn't occur to me to remember how I had come by it, until that moment. I was momentarily struck dumb, not by guilt or fear of punishment, but simply by wonder at the laws of the universe, the simple impossible irony of the coincidence that she would pick *this* day to ask *this* question, which she never had asked in all the days I had legitimately returned from Uncle Ira's chewing gum. Could she tell just from looking at me that I had stolen it? There was much I didn't understand about adults, but this was an entirely new and unfathomable concept.

Her question was not repeated, but my mother's glare demanded an answer. I opted for the truth, knowing the alternative which came to mind would only escalate the situation from disaster to catastrophe, for obviously some Higher Power at work here had enabled her to see things which it was impossible for her to have seen. I took my spanking, and returned the country mile to pay Uncle Ira and apologize for my sin. Though I did not bear him any grudge, I remained in awe of him, for this as much as any other reason, for the rest of my childhood, spending much time trying to unravel the mystery. Eventually I simply came to assume that he, and my mother right along with him, was in possession of powers beyond my understanding.

Uncle Ira was among the few men in the village who enjoyed the company of its children. Having many of his own, one would think he would not have encouraged our presence, but he entertained and encouraged us to be about the store, even though we had rarely any significant commerce to conduct there.

Sometimes my mother would send me on my bicycle with

a dollar bill tucked into my sock, and instructions to return directly with four loaves of bread and the daily newspaper. I remember once lingering so long with the other kids gathered there over Uncle Ira's antics, that I forgot what I had come for, and rode all the way home without ever once feeling that I had had a purpose for the trip other than to spend the nickel of my own, which I had taken along for my favourite, shoestring licorice. It was the second spanking I received in connection with Uncle Ira's store, and the second time I had to return the long mile straightaway. And still it was my favourite place to be.

I particularly loved to watch, from the safe distance beyond which we were not allowed to go, Uncle Ira cutting lunch meat with the machine of which nightmares were made. I stared in fascinated horror as his hand moved rhythmically from the very edge of the spinning blade to pluck the slice of bologna (correcting our "baloney" pronunciation with the proper "bal-owe-na") before it fell, place it on the growing pile of slices laid out on top of the brown-paper lined scale, and dart perilously close again to the razor sharp and rapidly whirling blade in time for the next slice. He never missed a beat, and the spectacle that such a miss would provide rivetted my eyes to his hands. I used to surreptitiously check the tips of his fingers, sure that at some point the machine would get the better of him. I never found evidence of it, though. Those deft fingers flew over the brown wrapping paper, creating with rapid precision the neatly wrapped bundle and pulling down string from where it was threaded over our heads along the length of the counter, tying and breaking the string, all the while carrying on a conversation with the housewife who had ordered the meat. He was a wonder!

Uncle Ira enjoyed our open-mouthed fascination as he took an egg from the paper trays kept in the glassed-in

refrigerator case, cracking it on the edge of the counter, and eating it raw from the shell. To this day, I don't believe he actually liked raw eggs, but only did this because one of us had once expressed the belief that he wouldn't, and he'd found that it shocked us to an extent that proved worth his while: we were all in awe of him.

It paid to have the village children in awe of him, because each Saturday afternoon we could be found in the back room of the store, playing various instruments with degrees of skill that ranged from the nerve-wracking to the inspirational. For among his other talents, Uncle Ira was best known as The Music Man. He had organized and trained the North Buxton Maple Leaf Band, whose membership included all of the youngest, and many of the older citizens as well. Everyone in the village had at some time taken musical instruction from the man who seemed to know how to play every wind instrument from the trombone to the tuba, with percussions thrown in for good measure. But when Uncle Ira played the trumpet, the instrument would speak to us, wailing of hot summer evenings or piping of brisk marches in the autumn chill.

My mother and one of my sisters played the clarinet, whose myriad of strange keys and gadgets never ceased to baffle and fascinate me. My brother and two of my sisters played trumpets. My other sister was a majorette, and her leaps and gyrations while twirling, spinning, throwing and catching the shining baton were a secret source of envy in my small and clumsy heart. As for me, I was a tryer of all trades, and master of none. The trumpet, glockenspiel, drums, baton and cymbal all fell victim to my attempts to read music, to keep in step, to remember the routines, or to play the right notes. I ended up carrying the flag.

Saturday afternoon band practices would see the raggle-

taggle group emerge from the store's back room to assemble on the village street in a semblance of marching order, practising drills as we trooped the streets of Buxton, providing a reason for the farmers to stop their tractors and listen awhile, the housewives to dry their hands on their aprons and come out on their porches to watch. Somehow Uncle Ira managed to whip us into shape by parade season, with infinite patience and no small amount of stern-faced discipline. He never received a penny in payment for his musical instruction or the time he spent drilling, educating, and entertaining us.

Often he did not receive payment, either, for groceries bought on credit at his store. Being a very small village, everyone knew who could and who could not afford what, whose children needed new shoes and were unlikely to get any, and whose large family consumed more than the father's pay cheque could provide. Uncle Ira made use of that information, conveniently forgetting to mail the grocery bills to those families until times were better, or until their pride would not allow them to do their weekly shopping and say "put it on my tab" one more time.

Uncle Ira's store, and the garage across the street from it, were the only business places which had survived the diminished population of the village. These, along with the two churches, were the only non-residential buildings available in Buxton, and were, therefore, its only meeting spots.

I never saw Uncle Ira in either of the churches, which accommodated all of the community with the same brand of religion under different names. Everyone knew who was a "Christian" and who was not, according to where they were on a Sunday morning. I don't know how Uncle Ira spent his Sunday mornings. The store was closed, of course; perhaps it

was his only time of contemplation, or relaxation, or simply sleeping in. I've come to understand that he did not care for the particular brand of Christianity which required one to be in the right pew on Sunday morning, but didn't care where one spent the rest of the week. But I do know that not one citizen of our village counted Uncle Ira among the non-Christian population. In a class by himself, he was. Not a church-going man. If they really had to define him, I suspect they'd have referred to another teacher, who welcomed the little children, and was likewise not often found in the organized church. As for me, when I contemplate Christianity, I don't think of those who were in their pew Sunday morning, or even of those in the pulpit. I can still find my best example in the life of Uncle Ira.

Share and Share Alike

— Just try one, Mel. They're soooo good.

— No thanks.

— Just one cookie! You won't get in trouble. I had one. She won't notice just a couple missing.

— Nope. Mom said not to eat them, 'cause they're for the bake sale, and you're gonna be in trouble when she gets home.

— How's she gonna know? There's lots. She didn't count them or anything. Okay, but you don't know what you're missing. They're still warm, and the chocolate chips are all melted. I'm gonna have yours then, if you won't have one.

— Okay, but I'm just having one, Julie. If anybody gets in trouble, it's gonna be you. Hey! You already had one!

— I'm just having one more. She won't miss three little cookies.

✤ ✤ ✤

— Oooooooooh, you're gonna get it now! Just wait 'til Mom gets home, Julie. There's only . . . one, two, three, four . . . five left. You said you were only having two. You're gonna geeeeeet iiiiit!!!

✤ ✤ ✤

— WHAT HAPPENED TO THOSE COOKIES? KATHARINE, AMY, JULIE, MELANY!!! IN THE KITCHEN, RIGHT NOW! You all heard me say not to touch a one of those cookies! Whoever did is in serious trouble. Well? Somebody better tell me, or you're all in trouble.

— I don't know, Mom.

— Me neither. I was upstairs doing my homework.

— Julie ate them. I told her not to, but she did anyway. Said she was just gonna have two, but when I went outside, she ate almost all of them, except those.

— Uh-uh! Not just me, Mom. Melany, you had some too!

The Little Brown Church in the Vale

"As for me and my house, we will serve the Lord," ranked
right up there with "spare the rod and spoil the child," in
Daddy's lexicon of lines to live by. Sunday mornings saw a
procession of the resident saints and sinners, regardless of age
or inclination, trooping out to pile into the family station
wagon, headed for the little brown church nestled on the
curve of one of Buxton's two crescents, or "back streets," as
we called them.

A vestige of the early settlement, religion was of major
importance to most of Buxton's families. Reverend William
King, a Presbyterian minister who had founded this refuge for
fugitives of the American slavery system by bringing the
fifteen slaves he had inherited to initiate this community, was
deeply religious. He instilled that spirituality in his charges as
he guided them toward self-sufficiency. And, like parched
sponges, our ancestors soaked it up. The God who had
sustained them through times of torment and degradation was
also the God who had, through Reverend King, led them to
this land of freedom, and they were eager to show their
gratitude. In learning to read, they began with the Bible.
Sunday services were held in King's home temporarily, but as
soon as all had adequate shelter, their first church was raised in
a community effort.

Not restricting them to reserved Presbyterianism, King
supported their efforts to establish the Methodist and Baptist
denominations active now. These, he knew, provided an outlet
for the more demonstrative forms of worship consistent with
the African background of the congregation. The respect for
worship and family attendance at service instilled in them by

King had survived the passing generations to become the prevailing climate in most Buxton households.

So when my sister Mel, ten years my senior, announced one Sunday morning that she was not going to church that day, I stopped mid-stride to watch the fireworks. Sure enough, my mouth was soon hanging open in amazement. It was not, however, the anticipated intensity of Daddy's reaction that had me dumbstruck. Rather, it was incredulity at his placid acquiescence.

I resumed my errand, muttering my six-year-old version of a diatribe on the vagaries of life, and was soon swinging my feet under the third pew to the opening strains of "Holy, Holy, Holy" as the service began.

The announcements, responsive reading, prayers, and sermon echoed through the little church and bounced off my consciousness, which was occupied with its own meanderings. Only the punctuating "Amen" or melodic "Well well" of Deacon Niles penetrated my thoughts as I admired his sing-song rhythm and tones. Though a full-fledged Baptist, our preacher was no gesticulating shouter, and his monotone delivery set me straight to daydreaming.

But the music brought me back again.

> ♩'m living on the mountain
> Underneath the cloudless sky

("Praise God!" interjected at this point by the more energetic of the mostly middle-aged congregation.)

> ♩'m drinking from the fountain
> That never shall run dry
> Oh yes, ♩'m feasting on the manna
> From a bountiful supply
> For ♩ am dwelling in Beulah land.

Rattling round the pews rather than ringing from the rafters, the dozen worn voices lifted in discord stirred my fertile imagination while the mysterious lyrics mesmerized me. The gleaming pew I shared with my father, brother and sisters became that mystical, mythical Beulah land, the scene modified with each chord Mom struck on the piano. I'd envision myself sitting on that mountain top drinking endless sodas and eating all I wanted of something heavenly. Not knowing manna from macaroni, my vision was uncertain on the shape, colour and flavour of the repast, usually settling on a cloud-white form of cotton candy, my version of elegant cuisine.

There was a lady in the village whose name actually was Beulah, but in her house everything was neat and proper, and an absence of children meant no toys, no games, nothing to do but sit primly on her livingroom sofa, half listening to the adults while you wished it was time to go home. I was sure this was no ode to her parlour, and conjured, instead, my own ever-changing idyllic setting of Utopia, incorporating the hues cast over our surroundings by the sun through the stained glass, the lighted cross and portrait of Jesus and Mary Magdalene which hung behind the pulpit, and the vases of dried flowers which adorned the little church. The sermon droned on.

The song I loved more than any other was "The Little Brown Church in the Vale." I had no idea what a "vale" was, but because I was sure that Mr. Alexander, who provided the booming "Come! Come! Come! Come!" of the chorus had written this song about our very own church, I assumed it to be the surrounding isolated land, rampant with wildflowers and supporting a wreath encrusted cemetery.

More than anyone else, Mr. Alexander seemed a personification of the church, his freckled hands pulling the

❧ • ❧

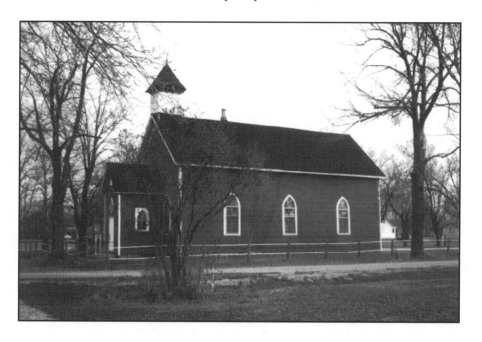

rope which called the tardy to worship. His demure demeanour belied his position as resident scholar in the community. He presided over the Sunday School classes with experience culled from his years as principal and teacher of Buxton's once renowned schoolhouse, and knew how to maintain order with a gentle hand. On the rare occasions when it became necessary to administer discipline with the leather strap that was standard equipment in the schools then, he would temper the punishment with the quip "I have to perform a little operation now." I associated his ringing of the bell in the steeple, a privilege he sometimes allowed us for good behaviour, with the invitation to "Come, come, come, come, Come to the church in the wildwood," and therefore knew it to be his song.

It was Communion Sunday, and I looked forward to the ceremony I knew would complete this day's service. My idea of pomp and circumstance, the dignified and solemn procession of deacons, my father among them, bearing trays of broken crackers and tiny glasses of Welch's grape juice to those among the congregation who felt themselves worthy of the Lord's Supper, was the most decorous ritual I had been privileged to witness. "And Jesus took the bread, broke it, and gave thanks, saying, 'This is My body, which is broken for you'" the minister intoned, providing the appropriate actions in the Lord's physical absence. "Likewise, the wine, saying 'This is My blood, which is shed for you.' And He gave them to eat and drink, saying 'Take, eat. As often as ye do this, do it in remembrance of me.'" And as he seated himself again in the pulpit chair behind the communion table, Reverend Prescott completed the pageant with "And Jesus sat down." The adults, so solemnly contemplative with their bit of cracker and thimble of "wine," told me this was no frivolous action. And Reverend Prescott's words "Whosoever partaketh of the

Lord's Supper who is not worthy, eateth and drinketh damnation unto his own soul,' confirmed the notion should there be any doubt. Simple saltines and grape juice, of which I might partake at home on any ordinary day, were somehow transformed here into something that would send you to hell forever after if you were to ingest them with unworthiness. I regarded my cousin Ned with trepidation one whole winter, sure that he would soon show signs of treading the pathway to hellfire, after I'd caught him sampling the communion leftovers in the little anteroom where they awaited their proper disposal.

"What can wash away my sin? Nothing but the blood of Jesus. What can make me whole again? Nothing but the blood of Jesus." The wailing strains of the musical quiz marked the completion of communion, followed shortly by the closing, "Blest be the ties that bind." Hand-shaking all around, and we were on our way. As Mom hadn't prepared Sunday dinner on Saturday this week, we drove the twenty-some miles to Chatham for a bucket of Kentucky Fried chicken, a stop at the Dairy Queen providing dessert. Daddy permitted no unnecessary work on the Lord's day, in fact inquiring of those who did work if their ox was in the ditch, this being the Good Book's only permitted exception.

Arriving home to find Melany casually outfitted in blue jeans and sweatshirt, in contrast to our Sunday best, and dining on leftovers from last night's meal of curried chicken and rice, I again marvelled at the unheard-of permissiveness my father was displaying this day. She was soon to learn the limits of rebellion in our household, though, and I was given a lesson in parent-child relations that was to serve me well in later years (without the necessity of learning it firsthand): "retribution is mine, sayeth the Lord," but fathers are the instrument through which I will exact it.

Two other rituals were invariably observed in Buxton on summer Sundays. The first was Burns's Beach. After church and Sunday dinner, Buxton's streets, and Buxton's houses, were utterly deserted. If you lived in Buxton, on summer Sunday afternoons you were at Burns's Beach, three miles straight south down the centre road. If you did not have a ride, you could simply stand near the south edge of town with your towel and wait. Someone would come along and pick you up.

Picking your way down the steep embankment to that section of Lake Erie, a clear view of the narrow stretch of sand below showed Buxton's entire census, swimming, snacking, sunbathing and socializing. From the community's eldest to its newborn babes, outings included all age groups socializing together. And there we all headed on this particular Sunday. With one exception.

One of Buxton's residents was not in attendance at Burns's this particular sunny Sunday, having discovered that it would be a frosty Friday before anyone who stayed home from church went frolicking afterwards. Mel was none too happy about this revelation, but nonetheless withstood it with the anticipation of the second of Buxton's Sunday rituals. Had she withstood denial of the second as passively as the first, she would have learned her lesson with relatively little commotion. But this was not to be the case.

Canadians are said to be born on a pair of ice skates. While we young Buxtonites enjoyed this national pastime, we rather preferred skates of the roller variety, and everyone between the ages of thirteen and thirty could be found at the roller rink on Sunday evenings. "Is it okay if I go roller skating, Daddy?" was one of those rhetorical questions, asked only because it was proper procedure. In actual fact the outfit had been decided upon, and ride arranged, before the question was

even posed. Mel, having suffered her afternoon's deprivation, considered her punishment complete, and had never considered the possibility of a negative response. The shock of receiving same must have caused temporary insanity, we later decided, because, as she stalked away, a muttered yet distinct "Go to hell" escaped her lips. We're sure she meant to only think it, didn't realize that the thought was uttered, could not have been so deliberately reckless.

Halfway up the staircase, stamping defiantly to her room, she turned at the sound of rapid, heavy footsteps directly behind her. Innocent of the fact that anyone had heard her parting remark, she was amazed to find herself face to face with the Lord's retribution. Daddy's stony face declared the purpose for the belt that had materialized in his hand. The speed with which he appeared with it was the amazing part. Too late she realized the limits of rebellion. None of us was disciplined with spankings much past the age of eleven or twelve. With one exception.

The church in the valley by the wildwood hosted all the residents of our household each Sunday thereafter. The exception had proven the rule for the rest of us, and we found further testing unnecessary.

Until she left home for medical school, where her rebellious nature found freedom in other outlets, Mel curbed the stubbornness she had inherited from our father. Sandwiched between siblings in the polished pews, a whole new light was shed for her on the uplifting chorus, "No spot is so dear to my childhood, as the little brown church in the vale."

Mothers at Three O'Clock

Glancing up from the mud hole we were digging, my filthy hand stopped mid-scoop, laughter dying simultaneously from my lips. The others looked up at me, but had not seen what approached over their unwary shoulders. My first inclination was to turn and run, but it took only a millisecond to think better of it.

They still were not close enough for me to make out their features, but it was unnecessary to see facial expressions. The rapid, purposeful, stomping strides were a clue. The willow switch gripped in the right hand of each left no doubt. We'd done something for which we were about to pay the piper, and the sight of our mothers' advancing column left no doubt the price would be high.

My cousins had by this time turned their gaze in the direction of my quaking stare, and I could see by their faces that their thoughts were taking the course mine had already traversed. Danny even took a few tentative steps in instinctive self-preservation before common sense and past experience drew him to a halt.

They were an army, marching in almost perfect synchronized stride toward us, each clutching her musket battle-ready. Not a muscle moved among us as we stood on death row, wishing we knew what sin we'd committed so that we could convincingly beg a pardon.

We could see the whites of their eyes now, and any slim hope we'd held that we were not the objects of their ire vanished as we beheld our fate in their expressions.

My Mom was slightly taller than the other two, and seemed inclined to reach us first, her long strides skimming the ruts and cow paddies strewn along the trail.

With this in mind, I knew I'd be the first to go, and scrambled in frenzy through my store of the day's activities, trying to match each possible error to the best from my excuse files. There was something nagging at the back of my mind that I knew I should remember, but in my panic it would not come forward.

The three angry faces were so similar that anyone would know they were closely related. Prince women were tall, their large bone structure evident in generous hands and feet. The current glower echoed in each set of similar features could not hide the trademark chiselled cheekbones which defined an aristocratic beauty even in approaching middle age. African princesses stalking their prey, spears at the ready: that was the uncomfortably vivid image that proved all too close to reality.

They were almost upon us when the thing I had forgotten finally surfaced. And with it the certainty that there was no hope of escape, for none of the excuses I'd filed would be able to account for this one: I had not seen my little sister for what must have been half an hour now, and I had no idea where to look.

"Where's Missy?" I hissed to my companions from the corner of my mouth, desperately hoping one of them could provide information that might save us at the eleventh hour. But the look that crossed both blank faces told me that they too were only now realizing she was not with us, and destroyed my last hope of salvation. We prepared to meet our fate, written not on the wind, but on the now-menacing faces of the women who had nurtured us. And, family being what it was, Jason and Danny were obviously to be held as accountable as I.

I knew Aunt Claire to be at least as strict as my own mother, both having been raised in the Sydney Prince school of discipline and applying it to their own broods with equal vigour. As for Aunt Sue, I'd once seen her break a wooden

spoon, albeit an old and brittle one, on the backside of Jason's brother, so I knew the three of us were in this for equal measure even though Missy was my sister. I felt sorry for them, while still harbouring some small relief that at least I was not to face it alone.

My seven year old sister loved nothing better than to tag along after us older kids as we invented adventures, tramping through ditches filled with tadpoles that became rivers of piranha, hiding under the culverts that were our pirate caves. If it were just Missy and me, I rather welcomed her company. Though I'd never admit it, I revelled in her adoration.

However, Jason and Danny were not merely cousins, but my best friends. When they were around, I didn't want to have to play with any little girls, and I resented Missy's constant interference in our plans. I'd had to prove to them that I could spit farther, climb higher, cuss better, and run at least as fast they could, before they forgot the fact that I was a girl and included me in their adventures. They both had only brothers, and I'd rather they not know that I played with a little girl in their absence. They'd never understand, just as Missy never understood my efforts to shake her off when in their company. "Why can't I come with you? I caught more tadpoles than you did yesterday, and I bet I can get more than them!" When we had to suffer her presence, we attempted what little French we knew from our classes so that we could converse without her knowing our secrets. For a while we used to spell things, but, perhaps inspired by this, she learned early to write down what we spelled, and sound it out.

When Mom had gone off to the church hall with Aunt Sue and Aunt Claire to help with the Strawberry Social, we were delighted to be left to our own devices. We were not delighted to be left with the child. Still, it needn't stop us from adventuring, and as soon as our mothers were out of sight down the road, we headed down the path which filed

between the weedy orchard and the cornfield, ending in a little clearing at the beginning of the woods we called "The Bush." Here, we could investigate rotted tree stumps or the inhabitants of entire hollow trunks. We startled rabbits, pheasants, or groundhogs from their hiding places, clambered over fallen trees and climbed healthy ones. Snakes, frogs, and turtles were ours for the catching. Hickory nuts and wild raspberries abundantly offered their bounty. If we ventured far enough into the woods, we would come out on the bank of the creek: at this season it was almost narrow enough to jump, but in others it ran probably five feet deep and twice that across, offering an entirely new range of diversions to entice three explorers like ourselves.

We ignored the child tagging along behind as much as we could. It wouldn't do to let my comrades know that I was actually minding her, so my occasional surreptitious glances to make sure she was still with us were disguised by feigned interest in something or other along the way.

But as we came across an unusually large snake hole in the soft earth, even stealthy supervision was forgotten. We had decided to dig and see if we could roust the monster that had made a tunnel nearly three inches across, uniform ripples of smoothed moist earth marking its entrance and identifying the architect. This was no little garter snake which had forged this tunnel, and the big ones were a rare discovery.

We'd excavated maybe twelve or eighteen inches into the earth by this time. I had just been thinking that one of us should go back and bring a spade, because even with three pairs of hands, the soil beyond the top few inches was dry and not so easily moved.

Knowing that snake holes had both an entrance and an exit, usually in close proximity, we were keeping an eye on the surrounding grass for the creature, and Jason said he figured a snake this size could take a pretty good chunk out of your

butt if he came up behind you digging out his hole. That struck me as pretty funny, and laughter raised my gaze from the ground, where it fastened on approaching doom.

Now, as they reached us, I had time only to note Missy, feet dragging despondently through the grass a good distance behind the angry trio, who in unison reached to grab the ear, arm, or shoulder each of her own prodigal child. The forlorn expression on her little face proclaimed the knowledge that we would certainly avoid her more than ever now.

Missy had gotten tired of being told she was too little to help us dig, and would only get in the way. She'd watched our progress for a time, and then began her only stereotypically feminine pursuit, picking wildflowers. Finding herself close to home when her hands were full of them, she had simply gone home, where the trio of moms had returned to discover her playing, alone, in the backyard.

You might have believed she had tattled from the expression of guilt now on her little face, but I knew Missy would rather have cut out her tongue, for it was a matter of principle which we shared. She was ashamed of having gotten us into such trouble, but it was small reward to us, as we were the ones dancing home to the tune of switches in the wind. Though we knew she was not really responsible for our present dilemma, she knew we would hold her accountable.

We all learned, that day, to guard the little girl closely. It was a practice which, as just retribution, was to haunt and harass her until her wedding day, when the man who loved her enough to persist despite our protective measures, won out. We had also learned, and it served us well to remember, another of life's little maxims: Hell hath no fury like a Buxton mom disobeyed—except three of them together.

We never did find that snake.

Seventy-Six Trombones

"Seventy-six trombones in the big parade, a hundred and ten
cornets close behind. They were followed by rows and rows of
the finest . . ." the tune trailed off here, as it always did, to a
hum, and from there to silence. I could never remember the
end of the song, but it didn't matter, because both my aunt,
whose hand I held, and my uncle bringing up the rear, were,
as always at this point, laughing at the vision of "woes and
woes" my pronunciation engendered.

It was our special song, for they had taught it to me, and
insisted I sing it to them, no matter where we met. I found it
strange that it always made them laugh as they sang along,
but I considered it a shared joke even though it was one I
didn't understand, and I felt privileged to have this secret link
to the adult world.

Making our way toward the bonfire on the beach, I
scanned first the shoreline below the embankment, and then
the water's rippling edge until I made out the dark silhouette,
against the star crusted horizon, that was Daddy, midway to
the top of his hip boots in the frigid lake.

I could tell by the way he moved that the homemade wire
basket net on the long metal pole was brimming with tiny,
shimmering, wriggling smelt. He was coming in to shore with
the haul. Aunt Sarah left me by the fire as she and Uncle Clive
each took a handle of the old washtub and made their way to
meet him at the water's edge to empty the squirming little fish
into the tub.

He turned back to the water for another pass. He'd
probably not have a second chance to get back to Burns' Beach
again during the brief smelting season, and he wanted to
make sure he had enough for one or two good feeds for

everyone this weekend, some for the freezer, and of course a couple of batches for Grandma and old Mrs. Clarke, who loved them so much.

The kids would be scaling, decapitating and gutting the tiny fish for hours on end tomorrow, and probably part of the next day too, but I was too young yet to be included in this chore, and could still relish the sight of such a good catch. Had Daddy been aware, as I was, of how often the kids pitched entire handfuls of smelt over their shoulders and into the weeds behind the bench where they sat in the sunshine at the task, he'd have made it a supervised chore.

The best tasting of the catch, though, would be those cleaned and cooked right here at the beach. Aunt Sarah had packed a frying pan, some butter, and some knives, and was now busy cleaning a batch to fry over the bonfire for our midnight snack. Uncle Clive waded out to relieve Daddy of the heavy net and take his turn at wielding it.

This was the first time I'd been allowed to come along on the twilight smelting expedition. To be included in this mysterious adult ritual was a rite of passage worth the nap I would be forced to take tomorrow afternoon. Driving out to the beach at midnight, picking our way by flashlight on the trail down the steep embankment, collecting driftwood and building a bonfire, watching the slippery feast hauled in and then digging my fingers into the net to lift handfuls of the squirming catch, their tiny scales coating my fingers and drying quickly in the breeze, was heady wine to an adventurous little girl.

We sang another chorus of "Seventy-Six Trombones" over the sizzle of the frying fish. At the inevitable mirthful ending, small effervescent giggles bubbled high over the adults' hearty laughter, which enveloped me like a warm and protective blanket against the evening chill.

The Wrath of the Sorceress

Mrs. Phillips had to be at least two hundred years old. Her excessively stooped shoulders, the shuffling gait, her frizzled white hair, the crumpled parchment of her skin, and the feebly crackling shouts which trailed us as we bolted the fence with a handful of her prized tulips, fuelled our already smouldering imaginations.

Mrs. Phillips lived in the little log house left over from the Settlement days. The cabin, built to the specifications of the old settlement, was far back from the road, surrounded by the required picket fence which bordered her lovingly tended flower garden.

We had all heard tales of her sorcery. It was said that she could make inanimate objects move, and some old folks swore to having seen her wood stove dance around the kitchen on one occasion, and claimed to have heard from the man himself how she had, without touching him, picked up a hefty fellow and set him on her kitchen table. Though we pretended to believe these tales, and delighted in embellishing them to frighten each other, we tended to put her in the same category as the bogeyman: a device of the old, to keep us in check. We dared each other to climb that fence and defy the wrath of an honest to goodness witch, secretly knowing her far too feeble to lay a gnarled hand upon our nimble persons.

One morning, though, a surprise awaited that day's delegate. The unlucky poacher who had accepted the challenge got not only the shock of his young life, but felt the business end of the witch's broom as she shuffled from behind a bush near his landing point. She wielded her all too appropriate weapon with the surprising accuracy of pent-up wrath long denied expression.

For at least the next month, we gave her laneway the widest possible berth, dashing along the far side of the road while straining to catch any glimpse of her lurking behind bush or tree. Thereafter, all rumours of her sorcery were greatly exaggerated. We saw to it.

Snapshot of the Universe

Though full-grown before proudly embracing my heritage, from the age of nine I was conscious of its weight on my skinny shoulders. Raised elsewhere, reality might have set in earlier in my life. But in Buxton, which was my universe, it was unnecessary to consciously contemplate race or culture. The heritage I shared with all about me was a subconscious awareness, natural as a heartbeat. Friend and foe, child and adult, hero and villain, those I looked up to, looked down on, or in varying degrees respected, feared, loathed, loved, learned from, all shone in bright and beautiful shades from tan to ebony. As if viewing the negative of the real picture, it had not yet occurred to me that in all of Canada we were a small minority. The real photograph escaped my notice. That vast country out there surrounding us, where I would be different, did not exist for me. Until I was nine.

Our farm was on the corner of the one paved road that ran through Buxton, and one of the many gravel concession roads. A mile north down that paved road was the centre of Buxton proper; a mile in the other direction was South Buxton. Back in the days when Buxton was the booming Elgin Settlement, our farm would have been smack in the middle of things.

There was no South and North Buxton then. The Elgin Settlement had had a population of over two thousand, mostly former slaves from the United States. Then it must have been a town of hope and wonder. Settlers who, for the first time since their ancestors were dragged from the shores of Africa, could enjoy the fruits of their own labour, made of this little clearing in the swampy bush a bustling and comfortable community. Confidence in the security of this

new land must have come slowly, growing only gradually as they built their first real homes, crafted with care by hands calloused with toil for others. Lord knows they were not strangers to hard work, but where drudgery before dawn had been routine, this labour of love had them happily rising before the sun, in order to accomplish more in its allotment of daylight. Forced for so long to neglect their families, or to try to forget loved ones sold away, in the Elgin Settlement they could raise cabins of their own, find a place where they could care for their families unmolested by the white neighbours around them, whom past experience had taught them to regard warily.

One of the early settlers buried a wooden box, obviously containing something precious to him, in his backyard beneath his rose garden. Only when time and experience had proven that he was safe in this new land did he unearth the chest that contained his freedom papers.

Cementing their ties to their new community began with the churches they built. Churches where every voice could lift and sing, to the God of their weary years, a song full of hope; a song not couched in the silence and secrecy of whispered double-meaning signals of the Underground Railroad, by which many of them had come to this place. In their own churches they sang to their God openly, praises of thanksgiving for leading them safely to a place where they could worship, marry, baptize their children, protect their families, and mourn their dead; thanks for bringing them to a place they could at last call home: raising, as they raised the rough-hewn rafters, a truly joyful noise unto the Lord.

And finally, but perhaps most significantly, the settlers established a school, where they and their children sat side by side for a time, finally free to learn to read. They read the Good Book. And when they had mastered that, their

enthusiasm for the education that had so long been denied them knowing no bounds, they went on to higher learning. As their school became renowned for producing achievers, it attracted the white children from the surrounding countryside to share these standards of education so vital to prosperity in this new land. It must have been amazing, even frightening, to these first settlers, to see their children encouraged not only to read and write, but to learn grammar and spelling, and Latin, Greek, Mathematics, sitting next to white children whose parents had actually requested permission to send them.

To see the bushy marshland cleared, tiled, drained, ploughed, planted and harvested, the neat multi-room cabins with their picket fences go up in community raising bees. Never having had anything, even themselves, that they could call their own, they must have fairly oozed enthusiasm for such tasks, determined to succeed because each success further verified that they were worthy of the life, liberty, and pursuit of happiness denied them in the land which claimed to embrace these ideals.

Each flower garden along the road seemed to surpass the last in its adornment of the countryside, creativity so long suppressed knowing no bounds in its expression. Survival instincts, sharply honed by slavery, found the hardships of carving a community in the wilderness mild by comparison, the challenge sweetened by the taste of freedom. No matter that some of their neighbours did not want them there. This was their home, for they had made it so, and the hostility of these few was but a drop to the bucket of their former life.

How they would have revelled in the freedoms that their neighbours took for granted. I can imagine the womenfolk, hands encased in mittens of wool from their own sheep, homespun skirts skimming the dusty road as they chatted in twos and threes, waving across to their neighbours on their

way to the little store for a sack of flour or a package of pins, for the first time experiencing the independence of self-determination, enjoying the company of others as they cared for their own homes and families, women working alongside their husbands and brothers and sons.

The tramway along the roadside would perhaps carry a team of oxen pulling logs from that day's clearing to the sawmill, lumber from the mill back to the lake for export, or brush to the new pearl ash factory. A wagon load of bricks would occasionally pass by in the road, the two drivers saluting each other, or passing the time of day as they waited for the train blocking the road to pull out of the station. The disembarking passengers would ask for directions to the town's hotel of those heading home after a stint of working the railway lines.

But in the once teeming, bustling streets of the Elgin Settlement, where industry and innovation had thrived, the fifty acre lots now merged into two, three or four hundred acre family farms stretching between the two small villages, scattered houses here and there proclaiming the depleted population, often deserted streets echoing forgotten footsteps of the founders.

For after the U.S. Civil War put an end to slavery, the majority of Elgin's population had returned to find lost loved ones, to pass on what they had learned of the value of education, the means to self-sufficiency, the keys to survival as free citizens. Now, South and North Buxton were separate towns. The Liberty Bell, a gift to the new settlement from a Black community in Pittsburgh, still hung in the church at South Buxton, where it had been rung with the safe arrival of each new fugitive slave to the settlement.

South Buxton was now a completely white town, and the bell was the community's only link with the remaining Black

settlers in North Buxton, descendants of the first to call this place their home.

Though the people at South Buxton were our neighbours, and we would wave to them when we passed, we did not know them well, and rarely travelled the mile in that direction.

The mile east down the gravel road from our isolated farmhouse took me to the little red brick, one room school house, S.S. #16, Raleigh. There was a similar school in Buxton, and I envied the children who lived within its boundaries. Buxton being our centre of social activity, its schoolteacher our Sunday School superintendent, its children our cousins and friends, we felt most particularly slighted at being excluded from its concerts, field days, spelling bees, and picnics. In fact there were about a dozen of us who lived on Buxton's border attending S.S. #16; together with roughly double that number of white children from nearby farms, we comprised the eight grades which filled the tiny room.

I would dally as long as I dared on my way to school, crouching at the edge of the culvert spanning the ditch and shouting to hear my echo, or pitching pebbles into the muddy water and watching the ripples. My brother, several years older than me, often accompanied me to catch tadpoles in a jar in the spring, and we would watch their daily progress toward frog if they were lucky enough to survive. But before school I dared not go down the bank for fear of slipping in and soaking my shoes, or getting burrs caught in my pant legs. Often I would wait near the road until I spotted a small group emerging from the house a mile to the west. They were a baker's dozen, and the third youngest was my best friend Lucille.

Lucille's family intrigued me, first of all because of their sheer numbers. In our house there were just two of us kids at

home, now that our four older sisters were engaged, in various stages, in the pursuit of university degrees, careers, and marriage. I could only vaguely remember when the youngest of them lived at home, and even my brother was so much older that I often felt I was an only child. But in Lucille's family there were enough children for a baseball team, with plenty of extras.

Then there was the fact that, though Lucille's father was Black, her mother was white, and spoke with an accent which Lucille said was French. When she pronounced Lucille, which she insisted never be shortened to Lucy or Lou, the name took on a lovely foreign sound that we children could not wrap our Anglicized tongues around, no matter how we tried.

Inside Lucille's house was a warm kind of chaos, a jumbled clutter of schoolbooks and newspapers, odds and ends of mismatched furniture, a shifting menagerie of pets and playmates, an abundance of noise and confusion, with an occasional injection of either stern discipline or affectionate banter. It was not uncommon to find one of the siblings kneeling in a corner for some infraction, while another would receive a quick and impulsive hug from the harried mother. It was a household almost diametrically opposed to my own, and I found its workings magnetic.

I would wait for the seven or so of them who were not either too young or too old to attend school, and we'd amble off together, my one little brown face hardly noticeable among their myriad of tan ones. In winter we liked to walk on the ice in the ditches, more often than not sloshing to class with a boot full of water from hitting a weak patch hidden beneath the snow.

I remember that first sunny Saturday in the spring I was seven, when I first went calling on my best friend, a box of crackers and jar of homemade strawberry jam in my carrier

basket. Lucille and I were inseparable. We were the same age, roughly the same size, and because there were no other little girls our age in the vicinity, we were each other's only option. The two of us were the grade one class. The following year, we were the grade two class. By grade three we had been joined by one of her older brothers who'd been left back a grade.

It wasn't a long country mile to Lucille's house. In fact, Mom could see me the whole way out the kitchen window. But to me it seemed an adventure. Lucille had been to my house on the way home from school a few times, but as I had no reason to pass hers, I had not yet seen inside the place from which all those kids emerged. And I was to be allowed to go alone, bringing a treat which I knew would make me a welcome guest.

I was flying over that gravel, and almost ended up head down in the ditch as I barrelled over a larger rock in the middle of the normally clear path worn down each side of the road. Managing, barely, to keep bike and rider intact and upright, I continued. As I wheeled into the laneway, two squawking chickens pursued by a nonchalant, sad-eyed beagle were my introduction to the wonderful jumble of life at Lucille's.

Two little girls eating crackers and jam on the rickety front porch steps: that was the beginning of my social life. My arrival home with the leftovers brought a stern reprimand from Mom for not leaving the remaining contents of the jar for the rest of the children. I was more bewildered than upset at her displeasure, for I really believed I would be reprimanded if I had left it. Thus began my social education. I would come to learn, much later in life, that there was one set of rules for Buxton, and another for the rest of the wide world. This lesson was never expressly spelled out, but began with my next

foray into friendship.

Lucille and I were joined, in grade four, by another classmate. Vicky's family had moved into the old Campbell house on the next concession, and her father was share-cropping for the man who had bought the place. The duet effortlessly became a trio, as the two of us adored the new arrival. She could run faster, spit farther, and swear better than most of the boys. She was the youngest of four children, and the only girl.

Lucille and I had been equals, and the introduction of a third might have created friction, except that Vicky became our leader. We followed her through ditches, over fields, into the bush. We imitated her coarse language, and began to affect her masculine stride. She instigated pranks such as stuffing the furnace vents full of dried milkweed pods before school: when the teacher arrived and turned on the heat, the classroom filled with the floating seeds. The ensuing pandemonium seemed worth the punishment of writing lines after school. A blond, blue-eyed picture of innocence, Vicky led us like docile sheep.

With one leader and two sheep, things went along smoothly. It was not until one of the sheep was removed from the fold that friction developed. Lucille and most of her siblings developed impetigo, and were immediately quarantined and unable to attend school. Being very contagious, and very ugly, the disease was regarded by our parents with the same loathing associated with head lice, and we were immediately forbidden any contact with our former companions. We took these warnings as an indication that there was something dirty about those kids, something shameful, an attitude that was to haunt them for years afterwards. I was sorry for my friend, but avoided her remaining brother and sisters just the same.

✤ • ✤

So, for several weeks that winter, Vicky and I were a twosome, and Lucille's absence created a new pecking order. The triad had worked well, because neither Lucille nor I resented Vicky's leadership when we were followers together. Being the sole sheep, however, quickly wore thin, and the friction of that resentment soon produced a flame. Never having had her authority challenged before, Vicky handled mutiny among the ranks in a completely predictable manner: she beat the crap out of me. Since this in itself was a new experience for me, I was ill prepared to defend myself, and quite ineffectual at it. Fortunately, though, Vicky didn't inflict any serious damage, and, as is often the way with little girls, our relationship probably would have returned to normal: having been put in my place, I would have been prepared to accept that place, with new respect for my leader.

We had attracted a small audience among those in the schoolyard who had noticed the fray, and I would have preferred to be beaten to a pulp than to be seen as a weakling. It was unthinkable for me to turn and run. Never having had to participate in an actual fight before, I wanted only for it to be over, but had no idea how to make that happen. Vicky solved that problem for me with her next action. Hauling me close to her menacing scowl by the front of my sweater, she growled loud enough for my ears only, "Haven't you had enough, nigger?" punctuating the question by throwing me to the ground.

She truly had had the last word, and her last word had a more powerful effect upon its quarry than she would ever be able to grasp. She had not managed to draw a tear or force a retreat with all her physical effort. She was baffled, therefore, and perhaps a bit frightened, when I burst into hysterical tears, dispersing my audience at the emotional display.

I had heard the word before. The older kids often threw it

at each other in jest, out of earshot of any adult. I knew its connotations, but regarded it as just another swear word. Until it had been used as a weapon to put me back in my place, and beyond, I had not known its power.

My brother soon heard what had happened, and before the week was out Vicky's older brother paid for her transgression. He was hefted over the schoolyard fence and into a pile of cow manure in the adjoining pasture. Vicky would have followed, except my brother was strictly forbidden to hurt a girl.

Eventually Lucille returned to school, and though the shame of impetigo followed her back, my humiliation at Vicky's hands was equally with me. We never spoke of either. Welcoming each other with the understanding that only fellow outcasts can appreciate, we renewed our former friendship, to Vicky's exclusion.

I felt some small satisfaction in my brother's vengeance. But I was never again to underestimate the power in that one word. I came to understand, and thus negate, its effectiveness later in life. But never to deny it. With the casual utterance, I had become aware of a world beyond my universe; a white sky where black stars would have to shine doubly bright just to be seen. It was an indicator of that second set of unspoken rules. My eyes were opened to the world beyond Buxton's borders, and I began to see the bigger picture.

Grandpa's Gray Dort

My grandfather, William Shadd, and his brother Flavius had a keen interest in things mechanical, which is why William found the impulse too difficult to resist when, on a horse and buggy trip to Chatham, he was offered a good deal on a car. Anxious to experience the new mode of travel, he stabled horse and buggy in the local livery, and was on his way.

One of the first to own a car in the area, he was undaunted by the lack of instruction in the fine art of automobile operation. Simply applying his mechanical aptitude to his "horse sense," he was soon feeling quite adept at the controls of his new machine. Tooling jauntily towards home, he pondered his wife's reaction to his impulsive purchase: she'd probably shake her head, hands on hips, looking at him in that "what will William do next?" way she had. Well, he'd simply have to take her for a spin around the countryside to win her over. If he could get her to climb in, that is.

Before home, however, he felt he had to go and show off his new car to his brother Flavius, the one person he knew would match his enthusiasm for the vehicle, a 1919 Gray Dort. The road through Buxton was still gravel then, and its dust billowed in clouds behind him as he flew at a reckless thirty miles an hour and turned down the next concession to Flavius's farm. All along his way doors were opening; all the residents of Buxton were on their porches calling across to each other as they watched his progress. "Wasn't that William in that thing?" "My, look at the dust." "That's the third automobile I've seen this month. Next thing you know the horses'll be ridin' in 'em."

By the time he reached Flavius's laneway, William turned

in like a man who'd been driving an automobile all his life, grinning from ear to ear in anticipation of his brother's reaction as he spun the wheel. He pulled smartly up to the barnyard gate, hauled back on the reins, shouting, "Whoa, there," and proceeded through the closed gate and into the barn before he thought of applying the brakes.

Months later he was still to refer to the car as an old sow when it misbehaved, smiling sheepishly when Flavius corrected him, "Shouldn't that be 'old horse'?"

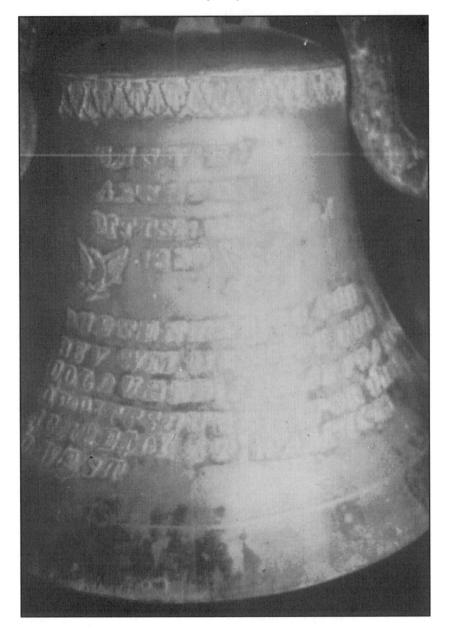

The Liberty Bell

—by The Coloured Inhabitants of Pittsburgh
and
The Coloured Settlers at Raleigh, Canada West
and
One Who Can Still (Almost) Hear the Bell

❖ ❖

Pittsburgh, 23rd November, 1850

To the Coloured Settlers at Raleigh, C. West:

. . . We rejoice that . . . You are now in a land of liberty, where the rights and privileges of freemen are secured to you by law.

. . . we send . . . a Bell for the Academy, that . . . will call your children to the house of instruction.

. . . and when the bell, with its solemn tones, calls you to the house of God, remember your brethren who are in bonds; and let your prayer ascend to God, that He may, in His own good time, break every yoke and let the oppressed go free. . . .

❖ ❖

Buxton, 20th January, 1992

To the Liberty Bell at the Elgin Settlement:

I hear your voice
across the fields
across the miles
across the years
through the forests
and the tears

I hear it still
 and still
I hear it

Bong. Bong. Bong.

You are the voice of Northern Star
Beckoning, your call rings far
 across the river
 over the mountain
 through the forest
 into the swamp
 throughout the plantation
 past the Big House
 at last to the quarters

Come. Come. Come.

We shall in glad response rejoice
Each time we hear your booming voice
For in the fullness of the sound
We hear the clank of coffle irons
Dropping empty to the ground
 no more the rattling chains we hear
 or crack of whip
 no gavel on the auction block
 nor moan from hold of foetid ship
 no yelp of hounds at heels in flight
 no scream of terror in the night

Gone. Gone. Gone.

Your echoed, humming aftervoice
Reverberates with mighty swell
Two thousand voices
Raised to tell
The message of the freedom bell

Sometime J'll climb
the stairs to see
the cracked old face
of Liberty
whose call rang first
to welcome me
And to proclaim to all
We have arrived.

Welcome. Welcome. Welcome Home.

Raleigh, C.W., 17th December, 1850

To the Coloured Inhabitants of Pittsburgh

. . . We are delighted at all times to hear from the friends that we have left in a land of pretended freedom, and although separated in body, we are present with you in spirit;
. . .
The bell has been raised to the place erected for it, and for the first time the silence of our forest was broken on last Sabbath morn, by its joyful peals inviting us to the house of God . . . we trust that while its cheerful peal invites us to the house of prayer, we will then remember our brethren who are in less favorable circumstances; and our constant prayer will be that . . . the power of the oppressor may be broken, and that those who have long been held in bondage may be set free.

Painted Lady Going Home

Her face was pale tan, the overlapping network of folds and creases suggesting there had been more fullness in her youth. A definitive layer of liquid foundation, dusted with pressed powder, deepened her natural skin tone to an almost-brown, and high on each cheekbone, a carefully precise circle of Dusky Plumrose.

Her eyes had been outlined in Charcoal, shadowed Royal Blue, highlighted Clearly Coral. Her mouth, perfectly bow-shaped still, was traced in Passion Pink.

The earrings she had chosen this particular Sunday were a quarter-sized circle of opalescent blue, rather plain to offset the large blue flower on the side of her pillbox hat. The matching brooch pinned her white lace shawl closed over the pale blue blouse. White gloves covered the wrinkled hands folded primly on the lap of her paisley skirt.

Her eyes never wavered from the picture of Jesus in the garden of Gethsemane hanging behind the pulpit as, head tilted to one side, she listened to the preacher wrapping up this day's sermon. Not until the organist struck the opening chords of "Leaning on the Everlasting Arms" did animation transform her face. Without visible effort her voice was fully an octave above the rest, head rocking from side to side with the hymn's rhythm. Her pleasure was evident, hands tapping in time on her cloth covered thighs. Her singing lifted the folds, separated the deeper creases of her face, where the foundation had failed to penetrate, making a road map of the carefully crafted canvas.

At the close of the service, she took her granddaughter's arm and they left their customary pew, second from the front,

right hand side, making their way slowly down the narrow aisle. She turned to each of the congregation who called out to her, stopping to chat while her granddaughter shifted from foot to foot, looking shyly toward the floor.

The pair made slow progress out the door and down the short block to her home. The granddaughter stopped long enough to see her safely inside the door before continuing down the road to where her mother awaited her.

The old woman closed the door behind her, pressing the lock simultaneously as was her habit. She turned to the closet beside her and, removing hat pin, then hat, and replacing the pin, she placed the hat in the empty spot on the shelf that it had vacated that morning. The other six hats of various styles lined up beside it each boasted a large and rather garish floral arrangement on side, front or back. The eighth, her Easter bonnet, was in a hatbox in the corner. It housed an entire bouquet, entwined with ribbons and delicate lace.

Using the door frame for support, she stepped out of her gleaming black patent pumps. As she bent to align them neatly in their appointed place on the closet floor, she did not see the reflected face which shone back at her.

Turning toward the kitchen, her right arm stretched instinctively above her to lightly grasp between thumb and forefinger the string threaded there to guide her steps. As it crossed another that led from the hallway to her bedroom, her hand floated, momentarily lifting at the intersection, and expertly reconnecting. At the kitchen door, she passed her hand deftly over the web of strings beginning there, determining third from the left, which would take her to the stove.

The kettle, still partially filled from breakfast, soon whistled its readiness. She had, meanwhile, replaced the lace shawl with a more practical cardigan. The soft swish of the

�֍ • �֍

slippers she'd retrieved from the bedroom closet accompanied her humming as she followed her string to the table. Preparing to pour, one finger looped over the edge of the cup to sense the approaching warmth when the tea neared its rim.

Beneath their shade and shadow, her sightless eyes fixed, unfocused, on the water-spotted print, a miniature of the one that hung in the church, but faded to pale pastels in its years of hanging over her kitchen sink. Barely discernible over the vibration of the aging refrigerator, sporadic snatches of the lyrics mingled with the tinkle of spoon on china. "I come to the garden alone," ping ping ping "while the dew is still on the roses. And the voice I hear falling on my ear . . . hmm, hmm, hmm hmm, hmmmmm, hmm hmm."

And He walked with her, and He talked with her, and He told her she was His own. And she followed one last string, her hand dropping from it as the riotous colour of His flower garden took her breath away.

Home to Buxton

Where have you gone, my people, my family?
Flown from the nest, on strong wings, but alone.
Gone to green tree tops, oh children of Buxton.
Gone to your destiny: nests of your own.

Wings nurtured here soar instinctively skyward—
Aspiring onward to summits unknown.
Many wings which began here had strength for
great distance,
But feathers of heritage turn their flight home.

So now you return to the place you remember.
Like trees you have flown to, your roots make you
strong.
And deep-rooted the ties that bind each generation
Instinctively singing our forefathers' song.

Your wings came from here. They were built for
endurance.
Free-flying, they've soared where you've chosen to
roam.
These wings will remember the place of your
nesting.
In annual migration, perch briefly at home.

Family, friends, Buxton's spirit of fellowship
Call you, "Take rest here, you've never been gone!"
Come, rest your wings with the flock of your
heritage;
Renew at your birthplace the strength to fly on.

A Rooster Tale

She's about to tell that rooster story again. Sooner or later, every family gathering ends in reminiscence, and invariably this tale swoops to land in ours. I felt its approach as a flurry of feathered wing tips grating on my skin, and my nerve endings were singed with a slow burn.

For here we were, reliving those memories of a childhood not so much shared as told and re-told, so often that I could picture events for which I am not even sure I was present. Being ten years younger than any of my sisters, the scenes they described were not really memories to me, but family folklore.

The rooster story was no exception. I can never recall the specific day that it took place. I have no recollection of their laughter, nor of my sense of helpless, hopeless panic as they stood and watched me fly around and around the house, with the rooster hot on my heels. It is true that some benevolent force usually helps us to erase from our minds those experiences which cannot be relived with any hope of maintaining sanity. But I was given older sisters who would recreate for me, over and over again, the scene my mind had managed to erase.

"There she goes." This accompanied by a rapid circular arm gesture to indicate my flight pattern. "There goes the rooster." More arm motion. "And there she goes again. And the rooster. And again. . . ."

The telling of the tale always ends (because there is, in fact, some justice in this world) with my mother's entrance onto the scene, and a swift and well-deserved punishment to those who only stand and laugh.

But with each retelling, I cringe inwardly at what I must presume was my dread panic. You see, while I don't recall this particular incident, I do indeed recall many similar encounters with the fiendish bird. So, knowing the rooster, and my siblings, I have no doubt that the story is true.

He was an ordinary looking bird, I suppose, to anyone who happened to see him strutting nonchalantly on his rounds between the muddy garden, which functioned as his insect pantry, and the chicken coop, which was his harem. But to me he was a vicious murderer, or at the very least, one who was capable of fowl play, and would think nothing of pecking my eyes out if I allowed him to get that close.

Soon after his arrival on our farm, he singled me out as the smallest and therefore most logical choice over whom to exert his authority. And exert it he did. After the first few encounters, I carefully avoided his presence, refusing even to venture outdoors unaccompanied. For a time my rooster tales were considered flights of fancy, for, with a cleverness I could not conceive the beast possessing, he feigned disinterest if I was not alone. But gaining the upper hand made him cocky, and soon enough his treachery was revealed. My father rounded a corner unexpectedly one day to find the bird hot on my trail, and none too happy to be caught at it. The shamefaced grin-and-shrug combination he seemed to affect at having been found trying to manoeuvre me into a corner, did nothing to delay the swiftness of Daddy's boot applied to his tail feathers.

I was elated to finally have had a witness to my plight, and my father, as always, was my knight in shining armour. Relief, though, was short-lived. Landing unceremoniously from his squawking kick-off, both dignity and feathers considerably ruffled, the rooster stalked away to brood upon the significance of this latest development. Now the old bird

was ready to take the game as serious business. He may have toyed with me before, but after feeling my father's wrath on my account, he had a score to settle.

Though our family farm was of a good size, as was our family, we were not farmers, me least of all. Since the arrival of the rooster, my mother had given up trying to get me to feed the chickens. With the time and effort it took to force me out the door, she could have done the job herself several times over. So the chore was relegated to one of those older sisters who had found my helpless flight so uproariously amusing. A just retribution, and perhaps the reason Sis now feels obligated to remind me of the rooster at every opportunity.

My father was in the business of moving buildings, and so our fields were rented out to local farmers on a sharecrop basis. But every available nook and cranny that was not given to growing things was crowded with trucks, machinery, steel beams, wheels, and all the other necessary odds and ends required to move a house or a barn from one place to another. In short, innumerable hiding places where one very angry rooster could conceal himself until I emerged.

I would quite cheerfully have remained indoors forever. To this day I am not an outdoor type of person. This may seem odd for one who was raised on a farm, and I think this particular rooster may have had a lot to do with it. In any case, the laws of the land quite clearly stated that, rooster or no rooster, I had to go to school. And this rooster knew the law. He took to lying in wait for me, never in the same place twice, but always somewhere on my path from the door to the roadside where, after they closed the little one room school down the road, I had to catch the school bus. After nearly missing the bus several times, which was not looked upon kindly by any parent who then had to drive you the twenty-five miles to the new district school, I became adept at timing

my exit. I learned that if I waited until I saw the bus out the kitchen window, and then sprinted from the front door at precisely the right speed I could, using the element of surprise, leave that fowl choking on my dust. Staying far enough ahead of him to arrive at the road just as the bus opened its doors, I would sneer my contempt back at him as they closed.

I was not so lucky on the return trip. Wise to my tactics, the rooster would no longer resort to subterfuge, but boldly scratch his feet directly in my path to the front porch, arch his neck, stiffen his wings, ruffle his dirty white feathers, and glare at me as if to say, "Okay. Come on, kid. I've got you now, and one of us isn't going to come out of this alive." At least, to my nine year old mind, that was his message.

Though the encounter my sisters found so extraordinarily funny has been mercifully blocked from my memory, I cannot seem to forget another day when I got off the bus to find that not only was my mother missing from her usual place of rescue, but, on managing to elude the rooster and reach the front door at full speed, I found it locked! Knowing my chances were slim, and my state near panic-induced paralysis, I fled back the way I had come. Taken by surprise, my adversary lost time in reversing direction, and was far enough behind that I was able to collect a fair sized branch that had fallen from the weeping willow under which I had fled. Its feathered branches draped about me might provide some measure of safety. And the branch which I now brandished just might prove the saving of my life, the weapon of my liberation, or at the very least, prevent me from losing an eye or two.

My bravado fled as insecurely as it had come. The bird knew I was bluffing. The drooping willow branches, of course, bothered him not in the least, and as he slowly

advanced upon me, his beady eyes reflecting the imminent thrill of victory, I'm sure I saw him grin. No doubt he had noticed that I was experiencing the agony of defeat, as paralysis of both mind and body loomed large on my horizon.

I knew I could not swing at him. I wanted desperately to kill the little buzzard with one mighty blow. I knew the lethal quality of a well-wielded willow switch. More than once I had experienced it first-hand, when some transgression occasioned my mother to direct me to go and retrieve from the tree the instrument of my own punishment. Looking back, it amazes me that I always came back with a switch in hand, knowing where I would soon feel its stinging wrath. But to risk returning without one would have been unthinkable. More often than not, I was in such hysterics by the time I returned with my switch that it was never applied. But I would agonize over the selection of my willow switch, debating, through tears already flowing in anticipation of what was to come, on exactly which size, shape, and age of switch was likely to inflict the least pain. I became adept, with practice. I knew that the oldest branches were likely to break with the first swing. But this would only make Mom angry, and then she was likely to choose her own for a second round. The thinnest, which I invariably chose before experience made me wiser, would sting like your backside had been sliced with a salty razor, and then disinfected with alcohol. The best choice, I had learned, was a branch of medium size, and only slightly aged. These didn't have much bite, and were not supple enough to last much beyond the fourth or fifth blow.

But I digress. In spite of this expertise, I had not had a moment to consider the merits of the switch I collected for my own protection, nor its potential for disarming my foe, but simply grabbed the first available loose branch. So I faced the bird uncertain of my weapon, and it must have been apparent

by my hesitation. It did not matter, though, for I realize now that I could not have swung at him had I been wielding a machete. For the scene which I imagined in those few panic-stricken seconds was one in which he flew at me as I swung, missed, and had no second opportunity as he landed in my face, knocking me backwards and claiming his ultimate victory, beak buried firmly in my eyeball. So I stood, afraid to miss, and therefore, unable to swing.

With wings outstretched, he assumed his pre-attack stance, rising almost imperceptibly on his chicken feet. It was too much for me. The months of his harassment had taken their toll. I could not fight. I could not run. I believed myself to be alone, and about to die. Heedless of the fact that the nearest neighbours, and thus hope of any help, were at least a mile away, I opened my mouth, and the throat which had, with the rest of my body, been constricted with paralysis, released the sound for which the phrase "blood-curdling" was coined. Once released, it had a life of its own. There was no one to hear me, but I screamed. Indignity, when one is about to face the most horrible death one can conceive, is not a major consideration. I screamed and screamed. My body still would not move, and the switch I clutched at the ready remained quite ineffective. But if roosters can be said to have an expression, then this one was saying "What the hell . . . ?"

Still arched forward, with wings outstretched in take-off pattern, he looked, in his uncertainty, a bird of a different feather. I'm sure he must have been rethinking the advisability, the necessity, even the wisdom of attacking this little person who had so obviously gone mad. Perhaps he was even considering the question of why he had ever felt it necessary to menace me in the first place. Obviously this had gone too far. In any case, whatever he was considering gave him pause, and that pause proved to be his undoing. I still

could not move (with the exception of my vocal cords), but the corner of my unblinking eye caught a brighter green through the willow's leaves that was my mother's favourite housedress. A few feet to the left and behind the uncertain bird, she had assessed the situation, and was advancing upon him.

I have felt my mother's wrath. If I had been a noble child, I would at that moment have felt sorry for that unfortunate bird. He had threatened my mother's baby girl for the last time, and his fate was close at hand.

I learned later that Mom had that day come down with the flu, and had locked the door to have a nap, intending to be up again before my return. She had overslept, and been awakened by my screams to find that the menace had cornered me yet again. That bird didn't have a chance. My mother, on a good day, was not to be trifled with. And this had not been a good day.

I don't recall whether or not I stopped screaming at that point. I do know that with the hope of deliverance, my paralysis fled, and so, then, did I. The last thing I saw before gaining the safety of the great indoors was my mother's hand, made strong by years of the innumerable tasks involved in raising six children on a farm, wrap itself around that bird's outstretched neck and prepare to literally shake the stuffing out of it.

My rooster friend was served up the very evening of his demise at my mother's hands. I believe he was stewed, and accompanied by her dumplings, the equal of which I have never tasted. No bird before or since, fried, roasted, baked, boiled, curried or creamed, has ever tasted so good.

Behind the Blue Door

I watched from under the broad leafed branches of the big old chestnut tree across the road as they came flying down the rickety flight of stairs at their top speed, not even slowing to look for traffic as they crossed the empty street to join me. Waiting for the inevitable teasing which would come when they'd caught their breath and finished giggling, I watched the weathered blue door at the top of the stairs to see if he had been drawn to open it yet again by their prank. As always, I allowed the others to believe I was too frightened of the old man to participate in the game, wishing I knew some way to prevent them from disturbing his solitude.

He was ancient; it almost seemed he'd been born an old man. Stooped almost double, his head was bent to the level of his waist, viewing only the cracked tops of his enormous shoes shuffling down the street to the little church, the only place I ever saw him go. It took him endless minutes to climb the steps again to the room above the general store where he lived. I wondered what the rooms looked like behind that forbidding blue door, if in fact there was more than one room. Of all my aunts and uncles, his was the only home I had never visited. I wondered how he filled the hours of his life behind that door, the brass pocket watch he sometimes consulted from within his coat pocket ticking away the time between church services. He could not tolerate the peculiarities of the average person, and preferred to live alone here in the place his brother Ira had provided.

Like his feet, his gnarled hands were huge, the knuckles bulging out the thin and weathered skin above massive fingers as he clung to the railing with one hand to pull himself up the steps one by one. The other hand held a canvas sack,

an old flour bag really, hanging down in front of him. He was
never without the sack, and sometimes would stop and
rummage through it on his way to church. I knew it contained
his Bible, whose tattered black covers and crumbling pages
proclaimed constant usage. Years later, when he died, I had
wanted so much to ask what else had been found in the sack,
but by that time I was old enough to know the impropriety of
such a question.

Winter and summer, he wore a heavy brown jacket,
opened at the front, which seemed to drag the stooped
shoulders even closer to the ground. Wooden clothespins,
whose purpose I could not divine, were clipped to one faded
sleeve. An old cloth cap topped the grizzled face, whose
sunken cheeks caved in upon themselves as he spoke. I never
knew if he had hair, or was bald like most of the other Shadd
men, because I never saw him without the cap.

He would speak to everyone, anyone, or no one in
particular. His speech was unintelligible to all but the few
who made the effort to get close enough to hear his soft voice,
and had grown accustomed to his murmured, garbled speech.
Uncle Ira, who supplied his dwelling and his necessities,
could interpret his mutterings, as could my father, who was
his baby brother.

I would stand beside my father as he talked to Uncle
Henry after church, straining to decipher the earnest
conversations by the one side of them I could make out. I
knew by Daddy's responses that they spoke about religious
things. Daddy said that Uncle Henry could quote chapter and
verse of most parts of that Bible in his sack. When they
conversed, it was not the ravings of a madman my father
responded to, but the observations of an extremely insightful
mind which had devoted all its energies to this subject.

Some said he had been kicked in the head by a horse when

he was a young teenager, and had never been right since. The tale seemed to be the community's way of explaining away a phenomenon whose defiance of explanation made them uncomfortable. In truth, medical practice then could provide no rational explanation for his condition. Alfred S. Shadd, his uncle, a prairie doctor and politician on a visit home when Henry was a lad, had noted the peculiarities which indicated advancing insanity in the boy, but he had been at a loss to explain it.

For a time he had been institutionalized. The hospital was in a beautiful country setting, but when his family discovered that Henry never left his bed the entire time he spent there, they made other arrangements for him. He was a threat to no one, and his needs were basic and easily satisfied.

So he lived out his life above the store, his weekly sojourn to the church seemingly his only activity, his Bible his only diversion. The children were afraid of the old madman, and while they scattered at his approach on Sunday mornings, they taunted each other with dares to climb the swaybacked steps and bang on his door. Occasionally several of them together would gather enough courage to actually do so, but only rarely did it ever bring him to open the door.

I watched the blue door now, hoping that he had not been disturbed, as I remembered how last Sunday I had held my father's hand as he bent low to speak to Uncle Henry at eye level. Uncle Henry's rheumy eyes had caught mine and held them in fascination as he spoke. As if recognizing his brother's child for the first time, his muttered stream of observation paused as he carefully inspected my sombre face. Then, with movements agonizingly slow and deliberate, his big old hand had reached out to touch the top of my head. Though I gripped Daddy's hand a little tighter, I did not move, keeping my eyes locked on his until the hand dropped

again to his side and he resumed speaking. Looking up to see my father smiling down at me with approval, and something else that looked like pride in his eyes, I knew that I had nothing to fear.

The Universe Revisited

My father had gone looking for the parents of the last two little boys to taunt me with the word "nigger." He had kept his temper in check and only given them a tongue-lashing in exchange for their promise that it wouldn't happen again. Though the reason was obscure to me, it seemed to make him maddest that they lived in South Buxton, which had been at one time a part of the Elgin Settlement. Ironically, the last name of one of the boys was Buxton, a distant descendant perhaps of the British emancipationist Sir Thomas Fowell Buxton for whom the settlement had been renamed.

For the past year and a half those of us who didn't live within the boundaries of Buxton's school had been hauled to various schoolhouses around the township by bus. This was some sort of organizational effort by the school board in preparation for the large area school that was being built to accommodate all the children from the various one room schools. This was our third school in that time, and in each we'd run into the bigotry of white kids who weren't accustomed to sharing their classes with us. My mother had taught me to read when I was four, and I was usually at the top of my class. This, coupled with the fact that I'd skipped a grade and was therefore younger than my classmates, made me a particular target.

But I allowed none of them to make me cry, and I'd strictly adhered to my father's edict not to back down from them.

But here I sat, the lone child in the classroom at recess, crying my eyes out.

It was not the name that had reduced me now to tears. I had jumped the girl and landed a few good blows before the

tide had turned in her favour. I'd ended up with the worst of it, but had emerged from the beating dry-eyed and defiant.

It was not until the teacher had escorted me into the classroom and inquired the reason for my uncharacteristic hostility; in fact, it was not until I heard her response to my indignant, "She called me nigger," that I cried.

Her eyes filling with well-meaning pity, she'd patted my shoulder above the torn sleeve of my yellow blouse and crooned in simpering tones, "And you don't like that, do you?"

I cried because I couldn't hit her too.

Her Grandma's Pearls

Her grandmother had been the family anchor, and emulation of that lady's strength still helped her over troubled times. Repeated often, the process was becoming less emulation and more inclination, and she could, like her grandma, provide a sympathetic ear or a sound tongue lashing, depending on which would do the most good.

The pearls of wisdom the old lady had dispensed in precise and sparing doses still came hard to her, but would come with time. For now, she fell back on borrowing some remembered, like the time, shortly before Grandma had passed away, when she had made her sit over a cup of tea one hectic, frazzled day in spite of her obvious rush. She had said "Girl, you've got a husband and three little children now. You have a choice to make. You can be a good mother, or you can be a good housekeeper. Long after you're gone, no one's gonna remember whether your house was always spick and span. Your son's trying to tell you about his day. Stop and listen." She could still hear the exact words, remember the precise tone, the tempered sternness in the woman's voice, and see the no-nonsense look above the wire rimmed spectacles. She had never forgotten that moment, nor the advice. It had been a turning point, and the current state of her kitchen was sound evidence of its effectiveness.

It was her day to cook the noon meal for the men coming in from the field. Her husband, his father and grandfather, the grandfather's two brothers, and one of their sons would all be in for dinner, and in a hurry to get back to the fields while the weather held. The meal had to be hearty enough to hold the six men until after dark, when they'd go to their own homes for supper. She had thick sausages roasting in the broiler; the

potatoes were finished and waiting to be mashed. Rolls were warming in the toaster oven. Tomatoes, from her dad's field, and cucumbers, from her own, had been sliced and seasoned and sprinkled with vinegar. Three pies were cooling on the rack, one of them slated for the Strawberry Social at the church hall tomorrow. The coffee was dripping its last drops as she set the table.

There might just be time to give the baby (who was nearly four but would probably always be "the baby" to her) her dinner before the men got in. The boys wouldn't get back from the playground program until after four. If she could get her mother to come stay with the baby, she might put in a few hours on the tractor herself this afternoon. She could skip tonight's museum board meeting for once. Lord knew they needed every available hand, with the forecast calling for more rain. Cleaning this kitchen would have to wait until after supper, and she knew she'd be bone-tired by then. It might have to wait until after the harvest was done for a good cleaning. But then it would be close to Labour Day, and the Community Club would be going full steam to get ready for the parade and the dance and everything. And she was responsible for planning the first PTA meeting the week the boys went back to school. Well, there would always be time this winter, if she didn't take on the six month contract job in town as she'd done last year.

She sighed and retrieved a jar of dill pickles, which her father-in-law favoured over fresh cucumbers, from the back of the overstuffed fridge. The baby ran into the kitchen with a crayon and a crumpled piece of paper. Beaming pleasure at her accomplishment, she showed her mother the indefinable all-green squiggle that was Daddy. "Mommy, write 'I love you Daddy' on here. 'I . . . love . . . Daddy.' It's for his birthday. Should I draw me on it too?"

She'd been about to transfer the pickles onto a serving tray. Instead, she took off the lid and set the open jar on the table. They could help themselves from there. She sat down on the stool at the counter. Pulling her daughter onto her lap, she wrapped her hand around the small fingers full of green crayon, and they wrote the words together.

ℋome and ᴄᴀway

"If I have to wear a dress, can't I at least wear this one?"

"You'll wear the new one I made you, and the subject is closed. Do you hear me?"

I wanted to say that I was standing three feet in front of her. I wanted to say that at the voice level she was using, I'd have to be deaf not to hear her. I said, "Yes, Mom," but then dared to venture, "But why do I have to get all dressed up, anyway? It's just a pancake supper."

"It's not 'just a pancake supper.' We're going to the one in Merlin this year."

I discerned the implication, and knew that she was enforcing another version of the same rule that said it was okay for my white classmates from Merlin, where we went to school, to wear jeans with holes in them to class, but we would never be allowed out of the house dressed that way. I had come to recognize when the rule, in one of its many forms, was to be applied, though I was still several years away from understanding its logic.

Still, it was all the explanation I was expected to require.

"And fix your hair, too, do you hear?"

In Dependence

A few years' practice had taught her the amount of pressure required to ease open the bedroom window, which she did now, without making a sound. She raised the screen and caught its latches in the frame. The last pale blossoms clung to the gnarled apple trees in the orchard, the knee-high weeds underneath displaying tiny blooms of yellow, purple, and white. She could have touched the pale green smoothness of half-grown maple leaves beside her, but did not. Like the walls around her, they would only be noted if absent.

To the right of her present line of tunnel vision, her mother's sturdy back bent away from the morning sun, hoeing weeds in the newly planted garden patch. Intent on her purpose, the woman occasionally bent to pull those too close to the sprouting seeds to be safely hoed away.

The almost-woman, too, was intent on the task at hand. Reaching under the dresser beside her, she retrieved the jar lid she kept hidden there. Further back, she found the pack of Cameo menthols. Only three left. She'd have to remember to get some this afternoon on her way back from Grandma's. She pulled the matches out of the pack, and lit a cigarette. The draught of mint-tinged tobacco relieving the craving which had lately become her first waking sensation, she relaxed against the wall.

She'd been smoking for almost three years now, and though it had started as an occasional thing, it was now an almost three-pack-a-week habit. A few of her friends smoked in front of their parents, but she doubted she would ever dare. She had heard that her father had smoked when he was young, but she had never seen him do it. And to picture her

mother even trying a cigarette was to laugh. Besides—any lengths to avoid a scene, had been her practice thus far in life, and it seemed to serve her well.

There had been a few occasions when her mother had come in not long after she had put out a cigarette. If the wind were coming from a contrary direction, the smoke tended to back into the room, like the wood stove downstairs, which occasionally belched its exhaust back at them instead of up the chimney. She was sure that Mom must know she smoked, although she had said nothing. Had Mom actually come upon her with cigarette in hand, she supposed there would be no choice but for an issue to be made of it. But barring any such unfortunate incident, she was relatively confident her mother would look the other way.

Thoughts ambling aimlessly over the day ahead, she puffed and blew, paused, contemplated, puffed and blew, occasionally shifting position to tap ashes into her makeshift ashtray.

"Missy," her mother's voice, more faint than it should normally have been. She wasn't sure she'd really heard it. Still, she quickly stubbed out her cigarette, which was mostly finished anyway, and fanned away the lingering tendrils of telltale smoke. "Missy. . . ." Again faint, but with a strange urgency in the tone.

Normally, she winced at the sound of this word. From the time she'd entered high school, she had managed, by repeated requests, to convince her friends, and eventually even her teachers, to shorten her given "Clarissa" to the more elegant "Claire," which she preferred. But here at home, she'd always been "Missy" to her family, the sound grating on her ear, reminding her of a shortened version of "Mistake." Now, however, that thought only had time to flicker by as the second call dispelled any doubt of its urgency.

In the kitchen, she found nothing out of the ordinary. The table had been cleared and her father's breakfast dishes neatly stacked on the drainboard. The bathroom door was open, and she could see that the tiny room was unoccupied. She passed the wood stove, still warm from the night before, and entered her parents' bedroom. A poorly aimed swipe missed the light switch beside the door, but she could see in the cool dimness filtering through the half-drawn blinds that her mother was not there. The familiar rumble of trucks and equipment as her father and his crew prepared for the day's work went unnoticed, the sounds as frequent a part of the morning as birdsong.

Returning the way she had come, she stepped outside, glancing toward the laneway, but turning instead in the direction the sound seemed to have come from. Following the path which veered slightly around the little hill of ashes where the garbage was burned, she found herself at a run without consciously willing it. Rounding the last little stand of evergreens placed to block some of the winter wind, she found her mother, who had not called again, but stood stooped over between two rows of the string beans whose bent heads had only just broken the surface. The hoe lay at her feet, across the rows and crushing a few of the new sprouts, soil still damp with morning dew clinging to its blade.

Mom's left arm was bent at the elbow so it crossed over her stomach. Her right hand clutched the arm, halfway between shoulder and elbow, in a grip that Missy could see had already bruised the skin. As Missy approached, she saw that Mom's normally coffee-with-cream complexion was now an ashy pale copper. She grasped Missy's wrist, eyes begging to be understood without the effort of speech.

Missy managed to guide her mother back along the path to the door, half pulling, pushing, trying to support her

weight. Her mother was not a sickly person. She could never remember her having had more than the occasional cold, and those rarely made her deviate from her routine. Like a phonograph needle stuck on a scratched recording, the one thought that played in her mind repeated "Someone should do something," to which her subconscious added at least three large exclamation points. Anything out of the ordinary was to be turned over to its proper authorities. Someone else "handled things." This was not her area, and should not be happening when she was the only one around.

She got her mother to the side of her bed, where she bent her knees of her own volition to sit. Recognizing her child's confusion, she expended what little strength she seemed now to possess. The effort twisted her face, jagged breath ripping her throat as she whispered the solution to the girl, who stood before her so obviously at a loss. The hand that rested on her mother's shoulder had been the only method of comfort Missy could think to offer, though her mind groped for some other. She leaned close to hear "Get your Dad."

Of course. He was still in the yard. She'd heard the trucks just a moment ago, and, yes, she could hear them still. Stupid. Stupid! Praying that he was not on his way out the laneway, she sped back out the door. Relief began to seep in, knowing that this crisis could soon be turned over to more capable hands. Left to her own devices, she may well have stood waiting for a solution to present itself until none was possible. Stupid.

Mom had been in the hospital for three weeks now. The heart attack had been a major one, and they had come close to losing her. But the danger was past, and the doctor had said she'd be home in another week or so. Home to complete rest

for a few weeks, and not to be overexerted for quite some time thereafter.

Taking care of her father's relatively simple needs had been a strain these past weeks. Missy was used to doing her share of the housework, but always under Mom's direction. The organization of it all remained a mystery. Dad hadn't complained when the meat was cold before the potatoes were half done, and didn't say a word about spaghetti three nights in a row. Still, Missy was conscious of her inadequacy in running the household. She was careful to be polite when Mrs. Clarke brought a casserole, thanking her correctly, before pushing it to the back corner of the refrigerator. Her father had raved over second helpings of the stew another neighbour had brought earlier in the week, and gone on for at least five minutes over how lucky they were to live in a community where folks looked out for each other.

Tomorrow night they'd have Dad's favourite, apple dumplings, for dessert. Rummaging through the jumble of papers and assorted odds and ends in search of Mom's recipe, Missy recognized the U of T course calendar she'd thrown into the drawer for future reference. Months ago, she'd written away to several universities, and then been so overwhelmed by all the information she'd received by return mail that she'd stashed them away to sort through later. Now, a few days before she would walk for the last time out of the school which had been her world for the last five years, remorse could not change what indecision had rendered. She had left it too long.

The other students in her graduating class all seemed certain of their choices, spoke with confidence of where they'd be come September. Of those, including Missy, who had marks high enough to be considered university material, most had applied and been accepted into their chosen programs.

One of the others was going to Fanshawe College, one was going to farm with his dad, and her best friend Laura was to be married this summer, and planned to start a family straight away.

She twisted the promise ring on her finger, searching her memory for the reasons her parents had insisted she must get a degree before marrying Albert. Something about education being the only way for Blacks, coloured people in her father's terms, to get ahead. "Especially a woman," he'd said. "I don't want you to have to depend on a man to get you by. You have to have a trade, like your sisters." Her family roster included a nurse, a teacher, a bookkeeper, a doctor, and her brother, who was taking over the family business. But in her father's vernacular, they all had 'trades.' It was a lot to live up to, difficult acts to follow. Neither of her parents had more than a high school education. She wondered if he considered Mom dependent on him, and if he resented it, or if Mom did. They were questions she could not ask.

Missy and Albert had been dating since she'd first been allowed to date at sixteen, and several times he had asked her to marry him. She'd put him off as long as possible, trying to determine her own feelings, and anticipating her parents' reaction. Then she had spent almost an entire month of evenings the winter past thinking up, discarding, and rethinking the best way to approach her mother. Marriage, relationships, sex, were all among the subjects they would never dream of discussing together. To approach the topic initially with an actual proposal required careful planning. In the end, though, she'd just gone into her mother's bedroom one night and announced "Albert wants to marry me," in her best conversational tone. Since Missy had yet to even finish high school, her mother, who had rarely shared a joke with her, apparently thought she was sharing one now, and

responded accordingly.

She said something to her daughter afterwards, but Missy never knew what it was, for she had fled to the safety of her own room, with the determination already in place that she would, indeed, marry Albert, in spite of her mother's response.

Missy heard secondhand how Albert had then come to the house one afternoon while she was at school and performed the ritual of asking for her hand. Albert's family were not Canadian, and did not even live in the area. Though Missy's father generally distrusted foreigners, the gesture of respect made its impression.

Permission had been given, if somewhat reluctantly, with the understanding that Missy was to first get her degree. In what field had yet to be decided, and the university calendars here in the drawer were evidence of possibilities unexplored.

Recipes and apple dumplings long forgotten, she sought the solace of her bedroom, where she could wallow privately in the self-pity dragging at her heels.

She desperately wanted someone to tell her what to do. The freedom to make her own decisions, which she thought she'd been longing for, had sneaked up behind her, and scared her half to death.

She remembered Grandma's anger. She had remarked to Dad that it was good Missy would be there to take care of Mom when she came home from the hospital. Dad had wasted no subtlety, letting her know that Missy was not finished her education, and would not be required to sacrifice her life. Frail but feisty, Grandma had sputtered indignant, spouting the inadequacy of any "other arrangements" Dad suggested. Guilty and uncomfortable, Missy had listened to it all without comment, studying the floor somewhere between their two pairs of feet.

She knew she should have spoken up. What a blessed breathing space such an excuse to prolong leaving home would have provided. Having witnessed the entire scene in silence, fearful that they might discover she had no plan at all, she was afraid even then to commit herself to one path or the other. She knew she'd never be able to tell Dad she would stay now. The opportunity had passed. He'd defended her right to leave, and by her silence she'd obligated herself to do so. The dilemma spun itself out in her head until the rampant vertigo of thoughts and emotions mesmerized her into the solace of sleep.

The hurricane of big plans, discarded plans, new plans, and no plans settled, sometime during the next few days, in the path of least resistance. Missy acted quickly on her decision. Before the winds could whip the maelstrom to a frenzy again, she'd packed her eighteen years of belongings into the round-topped antique trunk which sat in the corner of her bedroom, adding one small suitcase for her more fragile possessions. Soon after, she bid her father a rather stiff and formal goodbye, promising to take care of herself and to give serious thought to furthering her education. The two minute monologue was perhaps the longest, certainly the most intense, conversation they had ever had. Though her dad did not approve of this course of action, he would not stop her. Missy didn't recognize the significance of his parting "You'll always have a home." She felt more akin to a soldier without a country, deserting the regiment before the last stand.

She stopped by the hospital on her way, kissing her mother and performing the perfunctory goodbyes. A myriad of frightened and fleeing emotions fluttered close to the surface, and she dare not be more than precise. If one of those scraping wing tips scratched an exit, the entire flock might leave her screaming and skittering in their wake, flying about

the room in squawking cacophony.

As she left the ward and turned toward the elevators that would take her to the hospital's rear exit, she began the careful, calculated, yet totally subconscious chore that was becoming second nature: gathering her emotions back into the small and carefully locked trunk tucked away behind her memories. Deliberately, she focused her attention, and her hopes, on the man who waited for her in the car parked near the exit doors. And thought fleetingly that she desperately needed a cigarette.

The Women of Buxton

Your sisters in spirit,
Your sisters in kind;
Your sisters in heart,
And your sisters in mind;
Your mothers, grandmothers,
Their mothers long gone,
The women of Buxton
Have strength that lives on.
A determined spirit,
A purposeful will;
Your history, your future,
Your goal to fulfill.

To the woman of Buxton,
Her sights ever higher,
For she is a thinker,
A doer, a tryer.
Like her mother before her,
No stumbling block
Is too high or too wide
For she is a rock.

The first women of Buxton,
From where they have gone
Have left an inheritance:
We shall carry on.

Minetta

"That story you told me last time I was here was so sad, Aunt Minetta. I can't stop thinking about it. What ever became of Mrs. Gordon?" He was a connoisseur of local history, and had mentally stored the tale, along with a note to ask for further details.

"What story was that?" She was alert today, and chatty, her bright eyes focused on this nephew who often came to the nursing home to swap stories with her.

"About Mrs. Gordon? Nancy Gordon." Her eyes showed no dawning recognition, and so he prompted further. "You said she was six months pregnant, and one day when her husband was out ploughing the back field, their three year old daughter fell down the well." Still no response, but only inquisition in the ancient eyes. "You said she tried everything she could to get the girl out of the well, and when her husband came in for dinner he found she'd lost the twins she was carrying, that all three of his children were dead, and his wife nearly insane."

A smile began at the corners of her mouth and spread into a grin as she looked at him as if he were the one insane. "Who told you that nonsense?"

Observing the exchange, I couldn't help but laugh aloud, and he looked from his great-aunt to his cousin in bewilderment, now uncertain of the sanity of any in the room. I was used to Grandma's penchant for what Grandpa had termed "tall tales," and lately her memory had gotten so bad that she'd quickly forget she'd told them, making the unwary feel extremely foolish, and looking at you as if you'd lost your mind.

She was ninety-six, and had outlived her husband, one of her children, and all of her friends. In a rare moment of shared reflection, she'd expressed two sentiments on longevity that, in my comparative youth, I would never have otherwise considered. The first was that Syd, her husband, my grandfather, had had no business dying and leaving her here alone. It quite annoyed her that he'd done so.

The second was to protest the fact that she was still here, when all her friends had gone on. "I wonder what I'm left here for."

Here in the nursing home she was out of her element. Always an independent woman, she had refused to allow the county to provide even the limited help of an occasional travelling homemaker, and had managed alone since Grandpa's death, with the assistance of her two remaining children, and the grandchildren who lived nearby.

But in this place thirty minutes drive from the farm she had shared with Syd for much of her long life, there was little she could do for herself. The nurses, overworked with so many wheelchair-bound old men and women in various stages of senility, had neither the time nor the patience to allow independence. And so she existed, with only the incessant and unintelligible jabbering of her bed-bound roommate for company between her family's visits, waiting to join her husband once more.

She had grown up on the 5th Concession in Raleigh, then known as the Raleigh Plains. Minetta's father, Elbert Snarling Dyke, was the son of a slave woman and the white man who owned her. Born into slavery, young Elbert had been brought to the Elgin Settlement as a child and given his freedom by his owner, who was also his father. One of the first settlers here, Elbert became active in the community, helping to lay out the plans for the Elgin Settlement. He returned, at age eighteen, to

visit his father in Louisiana, acting for a time as teacher to his half brothers and sisters there before returning, on horseback, to Buxton. He opened the first post office here in 1875, and a small grocery store. In 1883 he became a member of the Raleigh Township Council, combining his community involvement with his other duties, and with raising a family.

As a young girl, Minetta had the task of reading to her mother's father, Charles Watts, who had come to live with his daughter Adelaide after the death of his wife. Another early settler, Charles was a rather fascinating character, named a Justice of the Peace for Raleigh in 1875. From this elderly grandfather Minetta learned the intriguing story of the two Charles Watts, both born on the same day, one the master of the other, a slave. The slave Charles followed his master onto the battlefield when he enlisted, and subsequently saved his master's life. The master's reward had been to give Charles his freedom. Even after the former slave had taken up residence in the Elgin Settlement, he had maintained contact and friendship with the other Charles for many years.

In line with her adventuresome antecedents, Minetta absorbed the footloose atmosphere and stubborn independence which earned her a reputation, at a time when women were expected to be content in the kitchen, as a spunky and headstrong young lady. Determined to make her own way in life, she enrolled at the Chatham Business School. Each day, in order to get to school, she first walked the four miles to Fletcher; from Fletcher, she boarded a train to Charing Cross; and from there, a streetcar took her to Chatham. The route was reversed each evening, being then the only means of transportation to Chatham and back available to her. But the independence that an education could provide was worth the effort to young Minetta. She was all of five feet, two inches, and at ninety-five pounds could hold her

own in any company with the quick wit that often poked fun at life's foibles, and the sharp tongue that chopped many an indignant superior male down a peg or two.

After graduating, she married Edward Robbins, and travelled with him to Western Canada, where he later died while serving with the Canadian Armed Forces in World War I. As a young widow, Minetta travelled the western provinces for some time, working occasionally as a teacher, and once as a Forest Ranger, when, among other duties, she was posted to spot and give warning of forest fires. She took various jobs to support herself and her travels, even working off her passage on a freighter in exchange for transportation to Japan. Minetta also spent time living and working in Battle Creek, Michigan, and in the Western United States, where an Indian Chief is said to have taken a dim view of her rejection of his marriage proposal.

About 1930, Minetta returned home to Buxton, having heard of the death of her cousin, Florine Watts Prince, who had been very close to her. She knew that Sydney Prince, Florine's husband, would need help with their two young daughters, and returned to care for the girls. Eventually, Minetta and Sydney married, and added a son to the family.

Like her father and grandfather, Minetta became an active member in the Buxton community, being one of the first members of the Who So Ever Will Club, founded in the 1930s, which made quilts and other goods to raise money for the maintenance and improvement of the British Methodist Episcopal Church. She was also one of the founding members of the Dramatic Club formed around the same time, which held plays and dances to provide recreation and entertainment for the community, and was responsible for the building of the Dramatic Hall in Buxton in 1935, where most community events had since been held.

The nephew who sat beside her now in the nursing home, grinning with me and looking like he felt more than a little foolish, knew the details of her early life. Like the rest of the community, he also knew of her skill in sewing and quilting, as well as in baking, which was an anticipated treat of any church or social function. He knew that she loved her roses, having dozens of bushes surrounding her home that she tended lovingly as long as she was able. And long after she couldn't get around very well any more, she could still spot, and identify, the countless birds who made their home in her trees. He knew that, too.

We had known her always as the perfect picture of a little silver-haired grandmother, baking cakes and making caramel corn at Christmas, and giving each of her fourteen grandchildren and twenty-two great-grandchildren a silver dollar after the Christmas feast we shared around her laden dining room table. It was difficult to reconcile this picture of the independent, adventurous young woman with the tiny woman who always spotted but could not catch us sneaking entire pumpkin pies out to the breezeway to be devoured before dinner, our frail little grandmother whose arthritic legs kept her sitting most often in a chair by her kitchen window. But her sense of observation was keener, her wit and tongue sharper, than most little old ladies we knew.

Her penchant for exaggeration being what it was, we'd found it necessary to check with Grandpa on the validity of the details of her exploits. He'd not only confirmed them, but filled in for her grandchildren some missing details.

A woman who knew what she wanted and went after it with a determination: she'd wanted an education, and she fought the odds to get one; she'd wanted to travel and experience life, and defied society's standards for females to do just that. When she'd decided it was time to settle down

and raise a family, it might have been as difficult a task for one of her adventurous spirit as her adventures would have been for the average woman of her times. Yet she'd applied herself to it with just as much determination, and success.

Now, Minetta had decided it was time to die. Though it made us uncomfortable, and we denied it, she had decided, and made no bones about saying so. She awaited death in this nursing home, facing it as she had lived, with a determined spirit and the anticipation of a new challenge.

The Dancer

He had stood up, looking back to check the load, just as the
wheels hit a good sized rut. That was how he had fallen from
the tractor, breaking a bone in his neck. He refused to accept
the betrayal of old bones directed by a mind still fancy-free.
The octogenarian with the lilting step was still a most sought-
after partner at community dances. Twirling his partner
through the two-step in perfect rhythm, his enjoyment was
evident in the spring of his large old feet as they rose nearly
six inches at each offbeat.

Apparently his bones were not aware of the agility of his
thoughts, and betray him they had, losing their balance and
toppling him so quickly that he had no time to counteract.
With a curse for the day's work now lost he drew himself
tentatively to his knees, and from there awkwardly to his feet.
Rubbing his neck in an attempt to assess the damage, he
crossed the furrows until he came to the relative smoothness
of the drainage trench, and followed it on home.

Some time later, his grandson, taking a load from the next
field, noticed the uncharacteristically idle tractor. He arrived
at the gate within a few minutes of the old man, who had, in
spite of his better judgement, put himself to bed. He'd rest for
a spell, he figured, and be right as rain.

But the boy insisted he go to the emergency. "All right,
then, let's get a move on. You don't look to be going back to
the field until I agree, and this crop's got to be got off while
the gettin's good."

The boy drove too fast, in his opinion. The stately green
sedan never went much over forty when he was behind the
wheel, and often slowed to half that as he perused the

countryside, taking in with minute detail the state of the crops of this neighbour, the addition going up on the house of that one. He could tell you for miles around which fields would be harvested too late to be of much value, which had too many weeds, what was good land and what wasn't, and why. The experiences of a long life he translated into observations surprisingly astute behind a face older than memory. He could have offered insight on subjects out of his realm, like marriage and babies, or finance, or folly. But experience had taught him to keep these thoughts to himself, and only those who knew him well knew the value of asking for them.

At the speed they were travelling, the countryside passed in a blur, and he was about to say so, only it hurt too much to turn his head; so instead he just closed his eyes against the glare from the windshield.

The doctor's prediction of at least a week in the hospital, maybe two or three, brought a muttered stream of protest from a face creased with pain, worry, and age.

"Now Grandpa, Dad and I will get those crops off in plenty of time. It'll be just fine." Dad had joined them at the hospital by now, and father and son both stood at the bedside, still incredulous at the thought of the old man walking home with a broken neck.

In truth, they could well manage the harvest without him, but for the first time they were facing the mortality of their patriarch, and they worried that forced idleness would crush his spirit just as surely as continued farm work might kill him. Maybe quicker.

Once at home, the neck brace that restricted his movement chafed both skin and spirit. "Go get the hacksaw, boy. I want you to cut this damn thing off." His son, far beyond boyhood and no less stoic than his father, only laughed with him and threw another log on the fire.

The Sunday School Picnic

He was there on the swing
By the time I arrived
At the Sunday School picnic
In Buxton that day,

And his heels flew like wings,
Propelling his motion
As children ran past him
And out of his way.

One hand held the rope,
And the other held her hand,
Her swing rocking gently
In time with his pace.

She knew that we watched them.
Her gaze focused downward,
Her shyness a contrast
To his open face.

He laughed with his son
And he smiled at his daughter,
Hugged his grandchildren,
And told them a tale.

He greeted his nephew
And waved to a cousin,
And tenderly picked up
Great-granddaughter frail.

He watched all the children
Play games and run races,
And laughed with the adults
As they played a few.

At the feast spread before us
He chatted with old friends,
And by the dessert course
I was his friend, too.

I'm glad I was there at
That Sunday School picnic;
He travelled soon after
To a higher plane.

Amid children swinging,
Though years piled upon him,
Still ageless in memory
I see him again.

Reflections–
The Return of the Hunters

Beside the scarred wooden bureau stood a polished rack containing some half a dozen rifles. Many of them were antique. All of them were enticing. None of them were loaded.

It occurred to me to wonder how we had grown up together, these guns and I, without ever becoming acquainted. While I had held various positions in the household from the beginning of memory until now, I had never held these guns. They had firmly maintained, during all those years, not only their physical stance beside the bureau, but also their unwritten sanction: we are not of your domain.

My father had taught my older brother how to load, shoot, clean and otherwise maintain each of them, beginning with those on the base of some scale as yet unknown to me, and working up. During the natural course of things, my brother had moved on to a life, and a place, of his own, leaving the guns behind to collect the coating of dust they now displayed.

But he must have been an apt pupil, for over the years, I recall them returning from various hunting expeditions with assorted small game slung over their shoulders, assuming a casual posture that belied the proud gleam in their eyes, my brother for his trophy, my father for his son.

The shorter excursions were usually to "The Bush," several acres of forest that comprised part of our farm. I knew the terrain, having often accompanied my father when he went to check the netted trap he set in mid-creek during the two seasons when fish were passing through. I loved to wander over the thick underbrush, scurrying back to my place

beside his overalled leg as he explained woodlore I absorbed but did not focus on. I was busy reflecting on the ludicrous possibility that there might be bears in those woods, or wolves, or at least foxes. I rather anticipated their appearance as a chance to see my father spring into action as the knight in shining armour I knew him to be.

Running my finger through the dust that had now collected along the barrel of the antique rifle in the uppermost place of honour on the rack, it occurred to me to wonder for the first time why my father had never taught me to shoot. I had not been invited on those hunting expeditions, but was always witness to their triumphant return, and often, though never willingly, participant in the preparation of the bounty for the table. Looking back, I recall a sense of envy even then. The knowledge of the craft I could obtain easily enough still, but the teacher has gone. To the end, I am sure, he would have been secure in the assumption that my place was on the home front, awaiting their return. And truly believing that it was my preference; why would it ever occur to him to have thought otherwise?

The closest we can come to knowing another is to share with that person a love of something: a child, a place, an activity, a memory. And to teach another is to leave some of yourself behind. I have some of my father. I want more. He was a fascinating man: kind and gentle, funny, reliable, caring and loving, strong and wise. The kind of man I would, as an adult, make a special effort to get to know better. To learn from. To share with. To spend time with. To keep a part of. But when I attempt to reflect upon him now, there is not enough of him there to see the real hero behind my childhood's mythical knight.

I see in retrospect why I envy my brother those times with our father. I think he knows, though, what a special thing they

were, his position as the only son according him their privilege. We, too, shared a special relationship, my Dad and I, but I was Daddy's little girl. That position came with its own rewards, and with its set of limitations: you can't shoot game from a pedestal.

Even before it was considered practical, my father taught me what he could of independence, encouraged me to think for myself, tried to make me self-reliant, to fight my own battles, and stand on my own two feet. A victim of the times, though, he could not teach me to shoot.

Slipping reluctantly from my reverie and re-entering my assigned domain, I picked up the cloth, removed the coating of gathered dust, and restored the lustre to the darkly polished metal.

Scotty's Children

During our early teens, while Dr. King marched in Atlanta, the coachmen, or lawn jockeys, displayed at a few of the homes in the county were the instruments of our own small statement of nonviolent protest. Going out by moonlight to remove these symbols of servitude and oppression, we painted their hideous grinning faces white, before returning them to their pedestals on the manicured lawns of their owners in the surrounding countryside. They considered them ornaments, and were either too insensitive to have considered, too ignorant to know, or too bigoted to care how much we hated the sight of them.

I omitted that particular memory from my narration as I answered Scotty's eager questions about the exhibit. I was pleased by his enthusiasm and his intelligent observations, which were hardly typical for most boys his age. I detected in his curiosity a genuine desire to know the history of this place, where ancestors on both sides of his family had originated. He was an inquisitive child, eager to learn, and my pleasure at his interest was reflected in detailed responses to his queries.

We were spending this sun-filled summer Tuesday inside a museum. I had reserved a few of my vacation days for Scotty and me to spend together, and this was the first of them. Normally, we would have been playing ball or flying kites in the park, but I'd planned this trip back to the little village where I was born because Scotty had a need to know. We came here each Labour Day for the parade and the rest of the celebrations. But a poem Scotty had written recently alerted me to the fact that it was time I acquainted my son with his ancestry.

His school was holding a Heritage Day, and his teacher had asked the students in the class to say where their parents were from. When Scotty's answer was Canada, she had asked about his grandparents. After another generation she'd gone on to the next student, with an exasperated look of disbelief. When Scotty related this to me, a chord vibrated in harmony with his feelings, as I recalled some of the times I'd been required to educate someone to the fact that there was a Black population in Canada even back in the early 1800s. The teacher had undoubtedly been searching for some Caribbean culture to animate the lesson, and like many who have made the same mistake, was disappointed in what she had thought was a sure source.

I had found the poem tucked inside one of his notebooks, in the careful script of one who has been admonished to improve his handwriting. The Heritage Day preparations had obviously raised some new questions, which he'd eloquently expressed in the poetic form he'd recently been experimenting with:

Africa, there on the map
Is large and full of hope.
But what is in this continent
Seen through my microscope?

Countries foreign to me,
With strange mysterious names.
I wish that I could point to one
And know from whence I came.

Looking closer still I find
Tribal community.
And in that tribe I see a boy
Whose face looks much like me.

You could be my brother, but
We can't communicate.
Should I be in your village?
Undisturbed, was that my fate?

We two should know each other;
We may share a common line.
But I can never know for sure
Which tribal rites are mine.

Did I come from Senegal
The Sudan, or Nigeria?
Were my folks Egyptians?
From the Congo, or Liberia?

Were my forebears warriors,
Goat herders, hunters, kings?
Was I "to the manor born,"
Or used to common things?

If my people had not been
Removed from motherland,
Would I have been son of a king,
Raised by a noble hand?

Or son of farmer of the soil,
Or of the village thief?
Was Shaka Zulu of my tribe?
Was Hannibal my chief?

Little boy in Africa,
Do you know you are my brother?
Do you care that as a baby
I was stolen from our mother?

Will you say that I'm not family,
That I do not belong?
Can you welcome my return
Into the village throng?

When I look close I recognize
Nothing that I know.
The place that is my rightful place
Is one where I can't go.

Africa is lost to me,
With no link to replace.
Who am I then, without a home?
Who is he, with my face?

Scotty was searching for his homeland. Sensing, perhaps for the first time, that though his ancestors had been here for generations, in the eyes of the majority he was not Canadian; yet knowing that he would be no more at home in Africa.

His examination, as a young teen, of a subject I myself had not defined until I was in my early thirties, filled me with pride. His eloquent expression of the universal quest of an uprooted people was remarkable for one his age. But I wondered if I had deprived my son of his heritage by choosing to live away from Buxton. Being raised here had provided me with the strong sense of self that Scotty was now seeking. I determined to give him something to hold on to, and to hold up, as definitive of his heritage. That much I could, should, and would do for my progeny.

It was not by accident that I had come to know the history of our forebears. Even before Canada's Centennial in 1967 when the museum had been built to house the increasing number of historical artifacts and information being amassed regarding our small village, the mothers and fathers,

grandparents, aunts and uncles of Buxton had endeavoured to teach us what they knew of our ancestry, where we had come from, what we had overcome. In an age when, south of the border, events were unfolding that would eventually ensure our place in society, an age when Black pride was not born but rediscovered, our parents had much to tell us.

My mother kept scrapbooks filled with clippings gleaned from local as well as American newspapers. The scrapbooks were a hodgepodge of information. Snippets about my cousins who had graduated, married, or had children. Photos, including my brother's singular brown face among the rest of the high school basketball team's white ones after they had won the regional championship. Articles about the church social, the fiftieth wedding anniversary, the local farmer's union. Pictures of cousins, friends, relatives, or anyone my mother knew who had managed to capture the attention of the press. Articles that she found interesting, some for reasons only known to herself. Articles about Black people, local or distant, famous, infamous, or obscure. News stories dealing with racial injustice, or justice done.

One article concerned a local wedding with some rather newsworthy repercussions, whose details I already knew, as did everyone in Buxton, but which I read with fascination anyway. An older cousin of mine (almost everyone in Buxton was a relative one way or another) had fallen in love with, and secretly married, the daughter of a Greek nightclub owner in Windsor. When news got out about the marriage, what ensued was like a scene from the cops and robbers shows I loved to watch, but with a bitter twist. The girl's family pursued the couple from Windsor to Buxton, where a police escort removed the gun her father was packing. The bride was taken back to Windsor by her family and held "in seclusion," but managed to spirit a missive of her undying

love to the unfortunate groom, whose father-in-law had threatened to shoot him on sight.

It was not a new story, in an age when Rosa Parks, who also made my mother's scrapbook, was expected to give up her seat on the bus to a white man. It was not an unusual story, at a time when Malcolm X and Martin Luther King, who shared those scrapbook pages, were fighting, and dying, for civil rights which would not stop south of that border. But it was a story which touched our little village personally, bringing home the era in a way that fired our young minds and hearts with a thirst for the knowledge, the information that would help us to further the struggle we so strongly identified with.

We grasped at anything that strengthened our awakening Black pride. Our heritage had been hidden away, and we were opening a trunk brimming with treasures needing only a polishing to remove the tarnish they had collected in their years of being locked away.

When our history classes at the high school in a neighbouring town had covered the era of slavery, we shifted our eyes within burning faces, trying not to meet the eyes of our white classmates, who looked at us then with a mixture of sympathy and superiority. Those early lessons contained none of the details of our struggles and our triumphs. The courageous men and women who had fought for freedom and civil rights for their own people went unnoted in the pages of our texts. Our ancestors, depicted in lowly servitude and acquiescence, liberated only by the beneficence of noble white northerners, left us feeling a shame we then felt guilty for feeling.

But as the stories that had been left out of those textbooks were unfolded by our parents, coming faster, almost, than we could absorb, we obtained a reason to hold our heads high

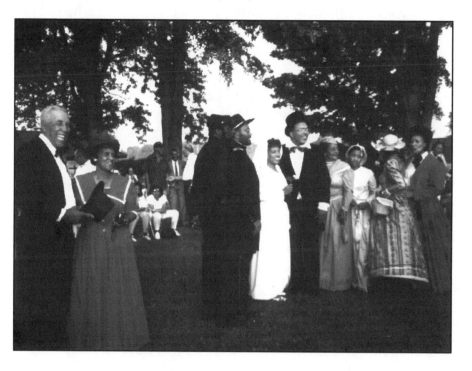

and deliberately meet the scornful gaze of our classmates and our teachers, filling in for them the details their lessons had overlooked. Though attempts were made to downplay our new information, they could not halt our burgeoning self-esteem, nor erase the new pride in eyes that now met theirs in silent defiance. The effects of our newfound knowledge frightened them, but its heady power left us thirsty for more.

Our parents, somewhat taken aback by our eagerness, scrambled to add to their own store of information the answers to our questions. In their search to fill our demand, they began to piece together our local history, and the foundations of the Raleigh Township Centennial Museum were laid, to house and compile our newfound knowledge.

It started as a Centennial project. It became a community effort the likes of which our little village had not seen since its inception. A population of slightly more than one hundred went to work to raise its share of the funds, which the government would then match. The days became rampant with bake sales, barn dances, quilting bees, strawberry socials and card parties as the ladies of Buxton once again put talented and creative hands toward the effort. Time spared from farms and factories was filled with preparing the land, improving the site, building equipment for the adjoining park; ideas and improvements came thick and fast, and were acted on just as quickly. The project so fired the imaginations of Buxton's young and old alike, that anyone who had a spare moment could be found at the museum site.

We learned so much more than history from our elders during this time. We watched my dad move buildings and equipment from the old park site to this new one, discovering how the beams, the jacks, the dollies combined to accomplish the task. I was so familiar with this process that it amazed me to witness the fascination it held for my friends, proudly

climbing into the cab of the big red truck with "Owen Shadd, Building Mover" emblazoned on its side, and inviting one or two of them to join me.

We learned that many hands make light work, and that no pair of hands was too small to contribute.

The boys fetched nails and lumber, cleaning up the scraps and unconsciously absorbing both the skills and the atmosphere, learning about community while they worked on carpentry. All hands pulled to the task: Uncle Arch Prince, Ervin Steele, Art Brown, Uncle Ed Shadd, Earl Prince, Bill Newby, Uncle Stan Prince, Dave Robbins, Uncle Ira. Those few who weren't relatives in actual fact were family nonetheless, and would often stop the saw long enough to explain why the wood was cut this particular way, or cease hammering to show what came next. The opportunity to wield hammer and saw under unobtrusive supervision, was an incentive for the boys to hang about for hours, sharing the banter and camaraderie. The girls joined their mothers, aunts and grandmas in sewing table covers, setting up displays, painting, polishing and sprucing up the little log cabin which was the centre of all our efforts.

And when it was complete, we all joined together for a day of landscaping, joyously digging and planting, fertilizing, watering, then admiring the flower beds, bushes shrubs, plants, and particularly the trees which would one day frame the little log cabin.

My mother became the first curator of the museum. Her compilation of the trivia in those scrapbooks ignited an insight into Black history and a determination to provide us with a sense of our own worth through the accomplishments of others of our race.

As Scotty and I entered the old schoolhouse, adjacent to the museum, where I had received my elementary education,

I began to experience the sensation described as déja vu. No longer used as a school, the building had been made an extension of the museum to house the "Living History" exhibit, now being worked on by almost everyone in the little village.

One room included miniatures of some of the buildings of the Elgin Settlement, while the back half of the other room depicted some of slavery's paraphernalia, as well as Underground Railroad devices. The front half of what had been the junior room had been preserved, or recreated, as the classroom it had once been.

This, however, was not responsible for the rampant déja vu I was feeling. The bustle of activity in these rooms now was so like the original building of the museum itself that, for a time, I could only lean against the wall, watching, smiling, remembering, and leaving Scotty to his own devices. He'd recognized some of his cousins, and was busy helping them pin up a display of old class photographs. As I watched him, I was struck by the rightness of things, as well as a pang of regret that Scotty was missing this way of life in a city where we didn't know most of our neighbours.

I had time to look over a few of the partially completed displays before my idle hands were noticed and put to work. You can take the girl out of Buxton, but you'll never take Buxton out of the girl, and I was soon feeling like I had never left home, giving opinions when asked and sometimes when not, trading stories and insults, gossip and laughter.

The concept of this exhibit had been proposed, refined and developed within the past year, and had taken off like imagination to employ the voluntary efforts of the entire community. And from the looks of things, they had undertaken it with a passion.

Over twenty years after Canada's centennial had seen the

museum in place, the children who had been coming of age in that era of historical enlightenment added their own dimension to Buxton's heritage discovery. It had become an era of communication, and stories of their heritage had such wonders as Nintendo and *Sesame Street* to compete with for their children's attention. Black history was much more widely known and available by this time, so the stories of Buxton's founding which we had absorbed with such eagerness became rather dry by comparison to the spectacles observed daily on television. Yet, like our parents, they knew their children's need to know.

Spare moments of young and old alike found them at the old schoolhouse volunteering time and effort to any task at hand, from building a miniature log cabin to sweeping up. In the afternoon we spent there, children stopped by with the question, "Need any help?" Fathers finished their day's harvesting and put in a couple of hours welding facsimiles of the coffle irons used in the era of slavery, bringing the finished product for approval. Mothers stopped in on the way home from the office to put the final flourishes on replicas of a school room, a country store, a log cabin. Grandmothers came by to pick up patterns and material for costumes of the Elgin settlement era. Scripts were being researched and written, placards lettered, and pictures hung.

Some doubts were expressed about whether opening day would find them ready. The arrival of the final exhibit piece brought a sigh of relief from most of those present when it was carried through the door. My own reaction, however, was one more closely resembling disgust: I could not fathom why it was included, and I turned my face instinctively away from the lawn jockey in his red jacket, hand upraised to hold the lantern above the cap that topped his grinning face. Searching garage sales and flea markets, they had had trouble finding

this last article, and I imagine there were quite a few odd looks in response to the strange request. But at the last moment someone managed to produce one from another city, and the display was complete.

Finishing my assigned task and trying not to disturb this beehive of activity, I had to know the reason this atrocity was to be included in the display. After it had been placed on its pedestal to a satisfactory angle, and a few other adjustments were made, the activity moved to another part of the room. I attempted to remain unobtrusive as I edged closer to the thing. They had tied a bandanna to its upraised arm. When I was close enough I stopped to read the placard, expecting to find some explanation of why we found it offensive, and still expecting to find myself offended at its inclusion here. But as I read the first few lines, I moved closer, fascinated by what I was this day learning.

Like many of the spirituals the slaves had sung which disguised secret messages of the route to freedom in their lyrics, these ornamental statues had assisted many on their way to Canada, including several of Elgin's original settlers. As the carefully lettered card explained, those lawn jockeys we had painted white to show our contempt had been used as symbols of safety on the Underground Railroad. If a scarf or bandanna were tied on the statue's upraised arm, it was a sign to the fugitive that here lived a conductor on the railroad, and it was safe to approach. No scarf signalled that perhaps the house was being watched, or some other danger threatened, and the traveller was best to continue to the next stop.

I can look at those lawn jockeys with a little more tolerance since that memorable afternoon. However, I couldn't resist asking one of my neighbours which of his ancestors conducted slaves to freedom on the Underground Railroad to which he paid tribute. The display disappeared from his lawn

by the weekend.

I reflected again on my sense of continuity, of the rightness of things, as my son and I finally took ourselves out of their way and found a picnic table in the adjoining park to continue our discussion. Many Shadds before him had been eager to know their history, to pursue education for themselves and their children, and to disseminate that accumulated knowledge in the education of others. Scotty seemed on the verge of continuing that tradition.

Much of the history of the Princes, my mother's family, Scotty already knew from listening to his grandmother, and his great-grandmother, who had only recently passed away. I outlined for him some of the highlights of his ancestry on the Shadd side of his family.

Many knew the story of Mary Ann Shadd, and of her brother Isaac, editors of the *Provincial Freeman*. Mary Ann was the first female newspaper editor in Canada, and the first woman of colour to hold that position in North America. Often when they heard our last name we would be asked if she had been a relative. But we Shadds were well aware that Mary Ann and Isaac were not unique in the family's history. Ink seemed to run in the blood line, and they were only two of many Shadds who knew the power of print and politics, more notable only because someone had written a book about them.

There was Dr. Alfred Schmitz Shadd, who had had his early education in the Elgin Settlement, and gone on to become one of this nation's first Black doctors. Somewhat of a prairie legend, he had edited a newspaper in the spare time his practice allowed him, and was said to be an eloquent speaker, as well as a very handsome man. Active in Saskatchewan politics, he missed by only a narrow margin being the first Black elected to a provincial legislature. And his reputation in the newspaper industry heralded him as "the

most brilliant editorial writer, bar none, on the prairies."

Locally, Flavius Shadd was legendary for turning the pen into a powerful instrument for social change. His letters to the editor frequented the *Chatham Daily News*, and his disapproval of the degrading term "Negro" is believed to have occasioned its discontinuation in the paper. His allegiance was to Canada, and his patriotism was evident in his missives. In noting that the Shadds had arrived in the Elgin Settlement not as escaped fugitives from slavery, but as free people of colour, he wrote, "We are Canadians by choice, sir, and not for lack of other options." Great Uncle Flavius referred to the fact that his grandfather, Abraham D. Shadd, had brought his wife Harriet and their children here to live in 1851. Abraham, Scotty's great-great-great-grandfather, had been an active abolitionist, a conductor on the Underground Railroad since 1831, both in Delaware, where he and his thirteen siblings were born to free parents, and in Canada.

Not long after his arrival, Abraham Shadd became the first person of colour to be elected to public office in Canada. He understood the value of education, and was instrumental in developing the high calibre school in the Elgin Settlement. He built a small school on his own property first, just outside the settlement, the Shadd School, which served area children for many years, and he chaired the initial meeting which resulted in the building of the Elgin Settlement school. His children were newspaper editors and writers, teachers, a doctor, and lawyers, sharing their father's involvement in politics, education, and social change.

This emphasis on education was passed on to successive generations of Shadds, and I hoped that Scotty's generation would continue it. I told Scotty about the Shadd Academy, recently opened in Montreal, in honour of the many contributions his ancestors had made, in particular to

education. The years had seen many more Shadds enter professional occupations, and many would be active in public education and social improvement.

Abraham's great-great-great-grandson had a great deal in his heritage to be proud of, and as I pieced together these stories for him, I could see that he knew it too.

Though Scotty still could not trace definite links back to Africa, he had found a place to stop along the way. Perhaps someday he might be the one to duplicate Alex Haley's successful search for roots. Or perhaps his wonderings would turn instead to the future. It didn't matter. What mattered was the expression in Scotty's eager eyes. I was glad that I had made the effort.

As we made our way through the park, emotions battled for prominence within: melancholy at what Scotty and I were missing here; pride in my heritage, and in my son; a sense of accomplishment in being able to help Scotty know his rich heritage; a deep attachment to this place, these people; the desire to linger; an unwillingness to let the spell be broken. I envisioned, briefly, what I hope was a premonition. I saw Scotty's children, climbing the trees I had helped to plant as a child so long before, maintaining the cycle of continuity. Their father would bring them here, I knew, for Scotty was beginning to understand why this would always be "home."

One Last Editorial

Mary Ann Shadd (1823-1893), eldest child of Abraham D. and Harriet Shadd, preceded her parents in immigrating in the fall of 1851 to Canada, where for a time she continued her teaching career. In 1853, she established the *Provincial Freeman*, a newspaper devoted to "informing and organizing" Canada's Black community. Mary Ann Shadd is widely recognized as the first Black newspaperwoman in North America, and was probably the first woman of any colour to edit a newspaper in Canada. Her younger brother, Isaac D. Shadd, worked with her on the paper for many years. Her life an advocation of the civil and women's rights she championed in the paper, Mary Ann Shadd was the only woman commissioned as a recruiting officer during the American Civil War; at age sixty she began a law career, having been Howard University's first woman law student. Mary Ann continued to edit, publish and develop subscribers throughout Canada West and the United States for the *Provincial Freeman* until at least 1859, possibly 1864.

What would you be doing now
Mary Ann and Isaac D.,
If your place in history
Were reversed with mine?

Would you write the daily news
Of a woman such as me
Who fought for equality
In another time?

Would I have the fortitude
To face oppression from a mass
That thought of me as lower class,
And publicize their wrongs?

Could I find the eloquence
To name injustice in our plight,
And point out ways to make it right
To disapproving throngs?

Mary Ann and Isaac D.
If you were alive today,
What would your newspaper say
Of our noble race?

Have we taken up the cause
Or would you say instead that we
Have taken on complacency;
Accepted second place?

If our editorial page
Were written by the two of you,
Tell me, have we followed through
On what you had begun?

Your descendants want to know,
Mary Ann and Isaac D.,
If you were here instead of me,
Would you write "Well done"?

Hands

Sheathed in the ceremonial white gloves of her Order of the Eastern Star, my mother's folded hands rested across her stomach, stilled, as they had never seemed to be in life. Beneath the pearl-buttoned gloves, they were large, for a woman's, the copper-brown skin stretched smooth over the front and extending down long, plumpish fingers, past generous knuckles, to cuticles often torn, worn, or gnawed. Her palms were tan, the smooth thick skin criss-crossed with darker lines of her life. The fingertips, sometimes callused or blistered, seemed as if they would not bear a print, so worn had they become over the years. Her nails, like mine, were often bitten to the quick, but occasionally she would let them grow to lengths that belied their usage and spoke falsely of graceful pursuits. The rings which Daddy had given her on their marriage had always been there, until now. I dare not speculate on how they got them off, for she had not been able to remove them for years, her knuckles having grown too large for them to slide over.

My aunt had once commented that my own hands are much like Mom's, and the comment stayed with me. In size, and shape, colouring, and general appearance, I believe my hands are much like hers. Even the rings she wore now reside on my finger, enhancing the illusion of similarity. In usage, though, I think my hands shall never be like hers.

I can still see those hands early Monday mornings, practiced and efficient, reaching into hot suds of the washer to feed the clothes through the wringer, and retrieve them on the other side. Attaching the hose that would empty the wash water into the sink, and then reversing it from the tap to fill

the washer with fresh water for the rinse. Repeating the process through the rinse cycle, always careful lest I come too close. Wringer washers had been known to snatch the fingers, or clothes, of small children, she would remind me, and pull them in to be crushed before the machine could be turned off.

Wash day Mondays then proceeded with hanging the clothes out on the line. Rain, or snow, meant postponing the wash until better weather, but sunny Mondays would find us in the backyard, where three thin sturdy ropes had been hung for the purpose. These were strung from trees to the side of our wood plank garage, which had once been barn red, but now bore a weathered, mellow grey streaked with maroon remnants.

My job was to hand Mom the clothespins as she moved down the line in her efficient fashion. I wonder now what went on in her mind during the assembly-line process which had over the years become routine. There was rarely any conversation between us during the chore. In fact, more than mandatory conversation was rare between us at all. I wonder now, looking back, what she thought about the world, about the status of women, the state of the economy, the spiritual realm, about her life, as she hung our clothes out to dry in the country sunshine.

It always fascinated me, and still does, that clothes would dry on a line in the dead of winter. After they'd been hanging in the snow-covered yard for the better part of the morning, I loved to reach up to feel the bottoms of towels and trousers, stiff with the frozen moisture, and wonder where, and how, the ice crystals would disappear by late afternoon. Often Daddy's longjohns would still be stiff when she brought them in from the line, and could have stood by themselves in a corner if she had had the time, and the sense of humour, to prop them there. But they, along with anything else too thick

to have dried in the winter sunlight, would be hung near the wood stove to finish drying by the end of the washday, which, with six children, a wringer washer, and clotheslines, really was a day's endeavour.

The hands that did the Monday laundry, the Tuesday ironing, the daily cooking, scrubbed and waxed and polished our floors, sewed our clothes, knitted sweaters, tended the garden, fed the chickens, and later wrung their necks and plucked their feathers; the hands that daily brushed and braided our nappy heads to send us off to school; the same hands that bruised themselves on our behinds to ensure we learned the difference between right and wrong, were the hands that peeled, sliced, boiled and canned our tomatoes, pickles, peaches, pears, jams and jellies; that baked cakes and pies, roasts, and kneaded dough for bread; that turned the pages she taught us to read long before we walked to the little schoolhouse on the corner; that tended our needs from babyhood through to adolescence, and meanwhile taught us to tend them ourselves thereafter; those hands rarely reached out to touch or soothe with gentle caress. They didn't hug, or pat, or stroke a young cheek, or wipe a tear, or tickle us relentlessly to helpless masses of squirming hysteria on the livingroom floor, as Daddy's hands often did. But on long winter evenings, when daylight was scarce, his time for such pursuits was not.

On such evenings, our mother's hands would fly over and under and through the intricate patterns of knitting needle and yarn, producing the soft, irregular tickety-click which heralded the creation of a sweater or hat or scarf to replace one worn out or lost by one of her brood. How I detested being made to sit with my hands outstretched before me and draped with a skein of yarn while she wound it into a ball for her next project. And how often I would end up tangling the

❧ • ❧

skein by my impatience, and endless minutes would be spent in the untangling.

Nor did I then appreciate the hours those hands put in at the sewing machine, for while we were better dressed than most others at school, I longed instead for the store-bought dresses my playmates sported, feeling they were the lucky ones because their mothers didn't sew.

I never knew how talented those hands were, as they met, and exceeded our needs. Time created by the advent of the automatic washer and dryer soon found her hands in more creative pursuits: unique and intricate decorations began appearing on our Christmas tree, our walls, and our table. Over the years I saw them take up millinery, bead work, smocking, quilting, embroidery, and countless other endeavours as an outlet for the creativity of a simple country woman which, had it been trained and marketed, would have been recognized. I saw it, though, as simply a mother's job.

During a rare leisure moment, Mom's hands would flow over the keys of piano or organ in the melody of the old hymns we sang in the little brown church on Sunday mornings. She was the pianist, or the organist, whichever took her fancy that day. The little congregation, if such a far flung title can be given to the dozen or so of us that lined the pews, would unite in song as Mom finished the opening chords that announced those familiar hymns from the battered hymnals which we all had memorized anyway. I can still hear some of the more memorable voices lifted in disharmonious worship, and often thought that perhaps Mom played the hymns at home only to hear their quiet peacefulness without the discords of a Sunday morning. But at home the hymns would often give way to a rousing chorus or two of "The Glow Worm," or "Teddy Bear's Picnic," which would draw us to the livingroom to march around and around behind her, arms

swinging and feet stamping our way into silly, wonderful, riotous mock parades. She would always give us a few extra choruses, though she might shake her head and sigh at our antics, never admitting that she was enjoying the frivolous moments as much as we were.

Like everyone in Buxton, Mom loved a parade, and was a mainstay of Uncle Ira's North Buxton Maple Leaf Band, which for years was a major component of the annual Homecoming Parade on Labour Day. Incongruously, seeing her white-gloved and motionless hands as she lay in her coffin reminded me now of those hands below the cuffs of her band uniform as she marched along, fingers flying over the intricate and complicated keys of the clarinet in a rousing rendition of "The Maple Leaf Forever."

If you were reared in Buxton, you would understand that Labour Day weekend when I was growing up was as exciting as Christmas morning. The excitement had little to do with going back to school. It was the culmination of months of preparation by almost all the hands in the village, climaxing in the Homecoming celebrations. During this weekend those who have left Buxton to take up life in other locales come home, to renew the ties that bind. Those who have never lived in Buxton, but only visited as children, return to renew old acquaintances. Those whose parents, grandparents, or great-grandparents came from here come back to renew the bonds of kinship. Here, as nowhere else, they can relax among friends with a truly shared experience. For here they are reminded of their roots, seeped in a proud heritage, and find the impetus to continue building a better life renewed as well.

The parade, of course, was the highlight to us children. I did not actually see one until I was almost grown, because like almost all of Buxton's children I was part of the parade. Those not old enough to be in the band were on floats, or riding their

garishly decorated bicycles, or dressed as clowns and turning cartwheels down the street. Or riding with their fathers or uncles in the antique farm machinery on display. Or waving from the front seats of convertibles whose backs contained the Miss North Buxton contestants. Ringing out from somewhere in each parade, the mirthful voices of the "Oldtimers" could be heard in bluesy strains of whimsy in "The Buxton Song:"

> There's potatoes in the oven
> And they're roasting nice 'n' brown
> There's a great big watermelon
> Just a-dripping on the ground
> In the pantry there's a chicken
> In the smokehouse there's a ham
> And I'd rather live in Buxton
> Than in Birmingham

No one knew where "The Buxton Song" had originated, or when, though the sentiment of relief at escape from the deep south was evidence that it had been around a while. The stereotypical menu that it served up brought smiles as the Oldtimers passed, and the familiar tune was echoed along the parade's route, the inside joke it shared proving laughter at our own expense could lighten the load.

Wherever their position in the parade line up, all were eagerly anticipating what was to follow, for the parade was only the beginning of the day's festivities: baseball games, cotton candy, pony rides, dunk tanks, penny arcades, clowns, a demolition derby, street dancing, all sorts of wonderful diversions among a crowd often two thousand strong. A veritable plethora of diversions, in a village of a hundred residents, where one was often hard pressed to find something to do, or someone else on the street to do it with.

A reporter doing a story about this phenomenon in the

little village the year I was six, asked me, "What is Labour Day?" I merely giggled, knowing that rudeness was never tolerated in our household, but thinking what a stupid question it was. I could hardly stand still, knowing the parade was only two hours away, and here was this grown person asking a question which any man, woman or child I had come in contact with would have known to be a ludicrous one. It was akin to asking "Who is Santa Claus?" but my upbringing, and Mom's watchful eye, would not allow me to tell him so. And so I only laughed at him, and wondered later if maybe the question had been a joke.

I held Daddy's rough and calloused hand as I skipped among the crowds of relatives and friends after the parade, dancing from foot to foot to dispel my impatience as he stopped to meet, greet, and "shoot the breeze" with, it seemed, everyone we passed. I wanted to see everything, but could barely see at all for the legs that surrounded me. Sometimes he would pick me up to sit on his shoulders, which felt to me like the top of the world, and I'd debate whether to plead for a pony ride first, or a hot dog, cotton candy, or go and see if the baseball game had begun. I'd stare in rapture at the Miss North Buxton pageant contestants, dreaming, but secretly doubting, that someday I could be among the pretty girls with their hair pressed and curled, looking as if they were ready for Cinderella's ball in their beautiful dresses.

My father would relax on Labour Day, and my fondest memories are of being with him then. I was his Missy, and he remained the only one who could thus shorten my name without stirring my ire. His hale laughter would ring out at some joke of a passing acquaintance, as his enormous and gentle hand rested fondly on my head. If there was a ferris wheel, he'd take me up on it, and as we reached the height of

the arc, he'd rock the seat, enjoying my exhilaration at the implicit danger. Labour Day was a rare respite for him. He worked six days in almost any other week of the year, sunup to sundown.

Daddy moved buildings. Since childhood, and to this day, I love to say that. His was a rare and noble occupation, a business built by him and his brother, and not many children can make a statement like that. In the "my dad's bigger than your dad" competitions of childhood, we used to say that our dad would put the houses on his back and carry them from place to place. In actual fact it was a system of raising the house off its foundation with jacks, similar to jacking up a car to change the tire. A pair of long wooden beams supported by portable wheels, called "dollies," would then be maneuvered under the house, and the house lowered onto the beams, which would be pulled down the road, by a team of horses originally, but in my lifetime by truck. In this way he moved houses, sheds, cottages, sometimes even barns, reversing the process to lower them onto newly built foundations at their new location, looking as if they had sat there since their construction. But explaining all that destroyed the mystique, and so we just told the other kids he carried them. We always won the contest.

I can still see Daddy's hands collecting the offering or serving communion in his function as a Deacon of the little church we attended each Sunday morning. The same strong brown hands that played Round-in-a-Circle or Eye-Winker-Tom-Tinker finger games with us, and could just as easily, though less frequently, administer discipline with a "spare the rod and spoil the child" firmness when required. The skilled and mighty hands that welded moving beams and bunk beds, Christmas tree stands and even a merry-go-round for us, would gently apply iodine and bandaids to a cut knee, or

mustard plasters to a congested little chest.

I remember Daddy's hands, as he lay in his coffin, like Mom's, were encased in white gloves. His were gloved in recognition of his Masonic order, St. John's Lodge #9, Free and Accepted Masons. As his Masonic brothers conducted a farewell ceremony before his casket, I resented their interference in the little time allowed his family for last goodbyes. I was instantly ashamed of the petty thought, for I knew that Daddy had been extremely dedicated to the Masons, as devoted to his lodge brothers as he was to anyone else in this world, except us. Raising us, he had allowed little time for other diversions, but his lodge meetings were a rare indulgence. His brothers were saying goodbye in their own way, and it would be his last communion with them.

Sitting in the hard backed chair of the overcrowded funeral parlour, I pondered the ties of kinship and community, comparing them to this lodge loyalty. Every available surface in the kitchen at Mom's house was at this moment crammed with ham, turkey, donuts, pies, salads, cakes, and casseroles brought by neighbours, many of them lodge members, most family in one way or another. With our spouses and children, we were a large family, and still it was more food than we could possibly consume in a week. The phenomenon did not surprise us; though we had little appetite, we understood this gesture of support during a crisis.

Strange that Mom's gloved hands should call up so many thoughts and memories of life, incongruous to my present surroundings. I should be concentrating on farewells, as it was to be my last opportunity. But my mind wanted out of this room, and perhaps, after all, the thoughts were more appropriate than it would be to bolt and run.

I remember the rare occasions when there might be a moment for romance, as we children trailed behind or ran

ahead on a Sunday afternoon stroll. I would see one from each pair of disparate hands, strong brown hands, brush each other and hold on, entwined for as overt a display of affection as we were ever to witness. Both pairs of large, calloused hands are stilled now, by the hands of time. No longer engaged by the chores of life, they are free to hold each other for all time.

Perhaps, after all, this is just the place where such memories belong.

electricity–a beacon

flickering lights show
the power is waning
current is drawing
but not like before

children are leaving
ties are not binding
strength dissipating
united no more

families drifting
what are we losing?
loyalties lessen
attempts are in vain

 can we hold on to
 what we once had here?
 shall we sustain it
 rebuild and reclaim?

or shall we be left
in the darkness unseeing
alone in the void
when it is no more

when it's all gone
how will we be warm
in the cold of the wide world
where we walked before?

links come asunder
lines unconnected
rush and renew
what we had in those days

 homefires still burning
 if we draw nearer
 warmth will rekindle
 a powerful blaze

Epilogue:
Eulogy for the Universe

I grew up on the 10th Concession in Raleigh. As often happens, I was attached to my familiar surroundings without ever knowing, or wondering, why. Perhaps I did not even recognize this attachment, as, on arriving at adulthood, I left for the greener pastures of city life. Please disregard the fact that there are no pastures, green or otherwise, in any of the cities I have known. At nineteen, the city is where one wants to be, and pastures are of minor consequence.

But after more than eleven years of city life, circumstances occasioned my move back to the 10th Concession in Raleigh.

It took a bit of getting used to. One of the major hurdles was remembering everything I needed when I went to the grocery store in Chatham, because there is no Macs or 7-11 to be seen on the entire length of the 10th Concession, and running out of milk usually meant doing without, at least for that day.

My other major stumbling block to readjustment was "critters." The moths, mosquitoes and other winged squadrons I was able to ignore for the most part. Crickets arrived in droves that particular summer, but I found the challenge of the hunt somewhat exhilarating. Mice, too, were a battle, but in the end I was triumphant.

Two of the legion of critters, however, still cause my heart to beat a rapid tattoo, while I beat a hasty retreat: those with eight legs, and of course, those with none. Now, spiders and snakes are by no means restricted to the country, but encounters in the city are so infrequent as to be negligible.

They say the mind has a protective device which blocks from memory those experiences too frightening to be recalled. I can only assume this must be the case with me, as I cannot recall there being so many encounters with these particular critters in my childhood. Except those occasions (too terrifying not to be recalled) when my big brother chased me with them.

Or could it be that years of city dwelling had reduced

mental defences previously built up to protect my quaking psyche? In any case, I have not yet managed to develop, or redevelop, the ability to control my fears on encountering snakes or spiders. I am, however, gradually learning to retreat with less quake in my quiver, and the time it takes to still my heart is ever decreasing. Perhaps, given long enough, at some point I'll be able to simply walk in the other direction, and have my pulse return to normal within, say, five minutes of our meeting. After all, practice makes perfect. And despite my best efforts at avoiding these particular neighbours, I do get lots of practice.

What all this is leading up to is the fact that this was only one aspect of Buxton living that had somehow escaped my notice, slipped my mind, or been buried beneath some mental block during my city sojourn. I had also somehow managed to grow up taking for granted the fact that some of the most beautiful sunsets to be seen anywhere are framed through my kitchen window on the 10th Concession in Raleigh, with nothing but miles of field and foliage to impede my view. I mean sunsets that literally take your breath away. Skies that gradually fill with oranges, reds, deep blues, purples, pinks, and all the various shades in between. It's such a gradual change that you don't notice, until you look up and a shifting panorama is laid before you for a few moments each evening, a scene that photographers are paid to depict in coffee-table publications. Right over my shoulder, providing the backdrop by which I wash dishes! I didn't realize until my return that during my years in the city, I had washed dishes seeing nothing more interesting than pavement, cars, and the occasional well-placed tree.

Then there are the fields. When you look out your window in the city, you can note the changing seasons, if you look for the signs. But here, you can't miss them. The entire scenery changes: from the rich brown sod of freshly planted fields in spring to full ripening green of crops in summer, the golden harvest-ready hues of autumn, and finally the bare grey emptiness making way for a blanket covering of winter snows.

Fields of corn, soya beans, winter wheat, tomatoes, cucumbers; orchards of apples, cherries, peaches, plums. My children had thought that the source of their supper was the

supermarket. Now they know the truth, know that autumn not only brings a changing and falling of leaves before Hallowe'en, but a hum of renewed activity in the fields and orchards which means the farmers are harvesting the crops that eventually will end up on those supermarket shelves. They know that the stuff they previously referred to as "dirt" is actually soil, not just for washing off hands and out of clothes, but the source of their food and their neighbours' livelihood. The entire inventory of this evening's salad they have seen delivered by generous friends or family, the abundant harvest of our neighbours shared, as we have distributed the carrots and green peppers from our garden that were far too many for us to consume.

They know that their milk comes originally from those cows they see daily. Real cows. Not fairy tale, picture book cows, but the ones in the pasture down the road.

And they've seen real rabbits, the way rabbits were meant to be. Distant relatives of those they knew from pet shop windows. Rabbits that work for their living, foraging, often in our garden, for their survival. Wild rabbits, that prefer it that way.

And chickens that aren't wrapped in cellophane, but lay the eggs we had for breakfast. Fish caught from streams near home and brought by their uncle (hoping to atone for the snake and spider incidents) for dinner.

And dark that is exactly that, when every star is visible, and not dimmed by a myriad of city lights.

The progression of stages from tadpole to frog is well known to my kids now, not from a science book, but from the ditch that runs along our road. And that ditch, which is the most subtle of science teachers, is also adept at botany. It fills with the most varied assortment of plant life, and the scenery there is constantly changing, beginning in spring with cat-tails and the glorious bright purple blossoms that accompany the developing milkweed pods, progressing through summer's Queen Anne's Lace, then into fall with a continuous shift in its riotous colour. As I write, a breathtaking array spills from the ditch, edging toward my neighbour's field, the purple, white and tiny yellow blossoms flanked by the feathery luminescence of the shorter foxtails, with here and there an early tiger lily eagerly poking its proud orange above the others.

Perhaps one of the more difficult adjustments my kids had to make in their transition to country folk was the idea that entertainment is where you find it. Not running next door (which is now a mile away) to see if the neighbour kids can come out and play, or sitting for hours in front of the television. But rediscovering each other as playmates, and finding wonders out of doors that were there all along. They would actually rather help me in our vegetable garden than watch someone else do it on *Sesame Street*, and have discovered the good feeling you get from burying your hands in sun-warmed spring soil, earth worms and all.

The advantages of the city are close by as well. We have to drive a bit for them, but Chatham has its share of entertainment when the country's charms wear thin. All the swimming, dancing, gymnastics or piano lessons my kids could take in a lifetime are right here. All the movies my husband and I could ever want to see, dining and dancing, bowling and bingo, shopping and sailing. They're all right here.

With all of these advantages, I began to understand why Buxton calls across the years to so many of those who have left it. But there was another element, some elusive key ingredient to its allure that I still had not identified. Most of Buxton's young people leave, but almost all return as often as they can, a large number come home to raise their own children, and still more move back to retire. It's not the name, the history, or the country setting that brings us back. It's the people, and the way of life.

The people maintain an attitude of small town neighbourliness, of support, of family, which is appropriate to our common denominators. The unfortunate effects of present day crime statistics are evident here as elsewhere. We lock our doors at night, and avoid picking up hitchhikers we don't know. The rest of the world is out there, and we have not isolated ourselves from it, but rather been insulated from its full impact.

If you need help, you can open your door and call to a neighbour in the street without thinking twice about it. I encountered engine trouble with my usually trustworthy but aging vehicle one day, and soon three of my neighbours,

passing by me on the isolated roadside, stood with their heads under the hood, seeking the source of the problem. They had all been on their way to work. But I was family. And this was Buxton.

Where else can one call a neighbour to help fix a broken water pump, knowing that when that neighbour needs a favour, they'll call on you in return? Where else would a meeting recess in order to round up the host's strayed dairy herd, and then resume as if after a coffee break. Where else can you feel absolutely unselfconscious attending any social function alone, because you will know everyone there, and be related to almost all of them.

This is the way of life here. And I sense its waning, and mourn its loss. Its pace is making way for the more hectic one of the rest of the busy world.

Before 1852, when Reverend King had successfully petitioned for a post office to serve the settlement, the often impassable roads to the closest one at Chatham had isolated the settlers from news and communication with the rest of the world. Since that first one, Buxton has always had a post office. Most recently located in a nook of the general store, it comprised part of the central informal meeting process of Buxtonites young and old. Picking up the mail allowed an opportunity for exchange of news, information, gossip and banter inside the community. Watching the red and white government issue sign removed, to be placed in the museum, was yet another signal of the end of an era. For the first time in over one hundred and thirty-five years, Buxton had no post office, and the daily informational exchange was replaced by a bank of locked and silent post boxes.

The seemingly casual dismissal of the local institution, an expedient decision to some government employee somewhere, soon heralded the end of another monument to the village life. Within months, the general store we had frequented as children, where band practices had been held in the back room, where Uncle Ira had entertained and inspired us, where we had agonized over which penny candy to spend our nickels on, closed its door forever. With the loss of the postal traffic, its commerce had finally been depleted beyond the point where any profit could be realized, and the loyalty of the few

who still shopped there gave way to the convenience of the supermarket chains in Chatham, where most of the village travelled daily to work anyway.

The local school had long ago been replaced by the district school in Merlin, where Buxton's children were bussed daily. Clubs that had previously provided their recreation, Tyros, CGIT, baseball teams, had all been replaced by those they joined at school or in Chatham.

The little brown church nestled in the crook of the back street still hosts a Sunday service, but most young Buxtonites attend the other church, on the main street, and the depleted and aging congregation struggles to maintain its expenses, determined to preserve it for as long as possible.

The community hall, which had housed teen dances and square dances, Hallowe'en parties and card parties, dramatic evenings and social evenings, has been boarded up, unused, for several years. Social events too large, or too inappropriate, for the church hall, now go out of town, to the rented hall of a nearby community.

In the 1850s an enterprising Englishman named Woods had opened a grocery store just outside the settlement's boundaries. Intending to cash in on the national practice of the times of unrestrained alcohol consumption, he obtained a whisky license, expecting a tidy profit from the trade of the booming settlement.

No formal boycott was organized; Woods was well within his legal rights to sell whisky in his store. But at a community meeting, Reverend King urged the people to withhold all their trade from his establishment if they were in disagreement with the practice. The settlers took their business elsewhere until the store's first cargo of whisky had been sold, a considerable length of time. Woods did not restock it, and business at his grocery picked up considerably thereafter. His first load of whisky was his last, and no one had ever tried selling it in Buxton since.

This community abstinence, which practice had been maintained since, now found its way to the bargaining table as the customs of the outside world encroached. The rising costs of staging the Labour Day events were overburdening limited resources, and the profits of liquor sales had to be

weighed against the values of tradition. Alcohol was in demand, and would draw a larger crowd. In the end, expediency won out, and the beer tent was raised amid sighs and misgivings. Another signal that Buxton was being moved into another era, and long-standing traditions moved aside to make way for progress.

Change is inevitable, and progress, I suppose, a desirable state. But the compromise is a loss: of a way of life, an indefinable spirit, a bonding of community that, once gone, may not be replaced, rebuilt, or rekindled.

Successive generations will benefit from the strength of those who came before. But they may not have what we had here. The circumstances which combined to create this atmosphere in a little patch of swampy bushland will, God willing, never be duplicated. Our children may no longer need Buxton's refuge, no longer want its solace from the world. We have arrived at a point where their stars can shine with the brightest in the universe and compete for their own space, and that is progress. But in all their glory, will they remember why they are strong?

Will Scotty's children feel any attachment to this place, know its people, share its spirit? Will they know why we'd "rather live in Buxton than in Birmingham"? Or will it be easier to read its history when they are grown, and say, "Yes, I think my grandfather was from around there," and never have to face the ghosts of ancestors, who built the dreams we take now as our due.

Roots & Wings

If I could give you many things,
I'd give you gold and silver rings
Of knowledge that I've gained with years:
The gift of smiling through the tears,
Confidence, courage, determination,
Laughter and spirit and love of creation;
Wrapped up in a box with a bow, I'd give
To you these gifts to keep for as long as you live.

"If I could give you just two things,
One would be Roots, the other, Wings."
Roots, not to tie you to the ground,
But to guide you to where your fulfillment is found.
The nourishing start, the firm foundation;
The source of your inner determination.
Wings to soar over obstacles, wings to fly free,
Wings to glide to the heights of the best you can be.
And when obstacles loom, from your Roots grows a
hand
Providing a strong, sturdy, safe place to land.
I'd choose these two things for the gifts that are
best,
For with Roots and with Wings, you'll find all the
rest.

The End
(A New Beginning)

❧ • ❧